QUICK & CLEVER
Acrylics

Michael Sanders

D&C
David and Charles

A DAVID & CHARLES BOOK
Copyright © David & Charles Limited 2008

David & Charles is an F+W Publications Inc. company
4700 East Galbraith Road
Cincinnati, OH 45236

First published in the UK in 2008

Text and illustrations copyright © Michael Sanders 2008

Michael Sanders has asserted his right to be identified as author of this work in
accordance with the Copyright, Designs and Patents Act, 1988.

A catalogue record for this book is available from the British Library.

ISBN-13: 978-0-7153-2677-0 hardback
ISBN-10: 0-7153-2677-5 hardback

ISBN-13: 978-0-7153-2678-7 paperback
ISBN-10: 0-7153-2678-3 paperback

Printed in China by ShenZhen Donnelley Printing Co. Ltd
for David & Charles
Brunel House Newton Abbot Devon

Commissioning Editor Freya Dangerfield
Senior Editor Jennifer Fox-Proverbs
Assistant Editor Emily Rae
Project Editor Geraldine Christy
Art Editor Sarah Underhill
Designers Mia Farrant and Jodie Lystor
Production Controller Kelly Smith
Photographer Kim Sayer

Visit our website at www.davidandcharles.co.uk

David & Charles books are available from all good bookshops; alternatively you
can contact our Orderline on 0870 9908222 or write to us at FREEPOST EX2
110, D&C Direct, Newton Abbot, TQ12 4ZZ (no stamp required UK only); US
customers call 800-289-0963 and Canadian customers call 800-840-5220.

CONTENTS

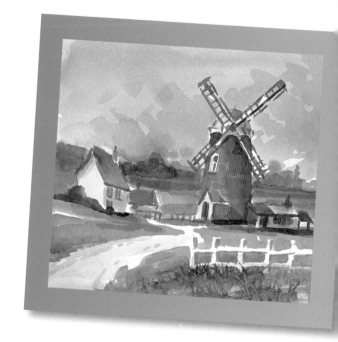

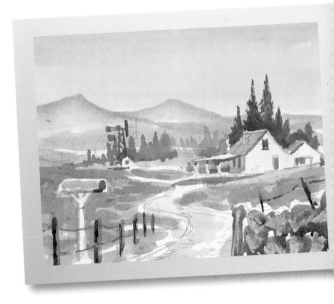

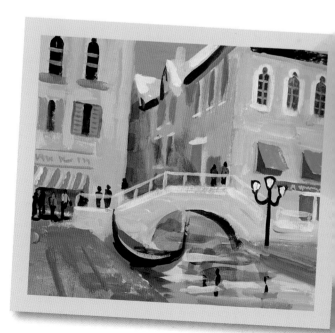

STARTING WITH ACRYLICS

Beginning your first real acrylics painting can be a little daunting, a bit like getting on a bicycle for the first time; all wobbly and hesitant. The difference is, with painting it does not hurt so much when you make a mistake! I would not worry too much about the occasional artistic disaster. You do not have to show your work to anyone else if you do not want to; it will be between you and me! Mistakes are all part of the learning process, and the important thing is to keep practising.

SO, WHY ACRYLICS?

I have been using acrylics ever since I went to art college in the sixties. You have to enjoy working with a particular material, and feel confident that you can make adjustments as you go along. For someone starting out in painting this is even more important, and acrylics are the most forgiving and versatile of all the materials available.

Acrylics are quick drying, so you do not have to wait for days before applying the next layer; and you can simply paint over your mistakes. There is no need for smelly solvents either; everything cleans with water.

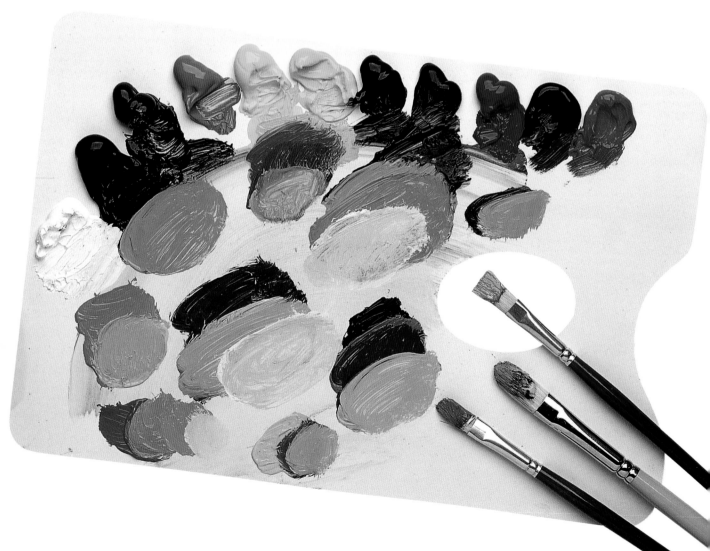

WHAT IS ACRYLIC PAINT?

All paints consist of a pigment (the colour) and a binder that holds the paint together.

Basically, all paints have a similar range of pigments in them; it is only the binder that makes it a watercolour, an oil paint, or an acrylic. The binder in acrylic paint is a polymer, which is a kind of liquid plastic. The paint is mixed with water and when the water evaporates the paint sets to become a very permanent, flexible layer, which can be wafer thin, or as thick as you want. It dries quickly, is not washed off by other paint being put on top, and can be made to dry slowly, or made more fluid, by the addition of retarding or flow-improving mediums. This versatility gives acrylics a huge advantage over watercolours, which can easily be washed off when other colours are brushed on top, and over oil paint, which may take up to a week to dry.

Acrylics are flexible and versatile!

OPAQUE OR TRANSPARENT

Another advantage is that you can use acrylics in many different ways. If you like the look of oil paintings and would like to work with thick, opaque paint to make textured marks, you can. If you admire the delicacy and softness of watercolours you can use your acrylics in a transparent way, with thin washes.

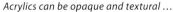

Acrylics can be opaque and textural …

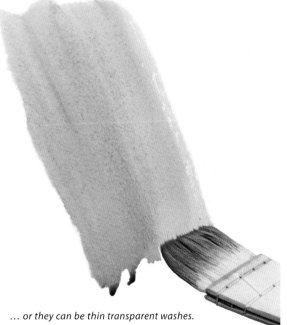

… or they can be thin transparent washes.

BE ACRYLIC CONFIDENT ...

Have you ever fancied having a go at painting, or seen a picture and thought 'I'd like to be able to paint that'? Have you tried and given up because you felt you were not 'artistic' enough? Perhaps you have been put off by the apparent complication, the strange-sounding jargon, or maybe just never had the time. If so, then this book is for you. You just need to make a start. In fact, you have already made a good start, by deciding to read this!

USING THIS BOOK

Throughout the book, I shall be using plain language with simple, straightforward exercises that you can follow to get you started on your first paintings. Working at your own pace, you can do a few simple brushstrokes to start with, or, if you feel more confident, tackle a complete painting as your first project; it is up to you to decide what suits you best.

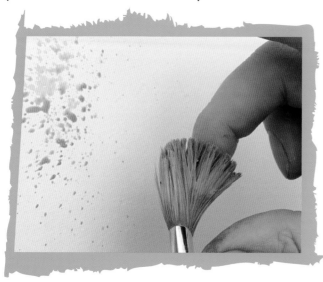

The book is planned progressively. We start with a look at the materials you will need and some basic information on using colour. This is followed by techniques for using acrylics, first in the transparent method, and then moving on to the opaque method.

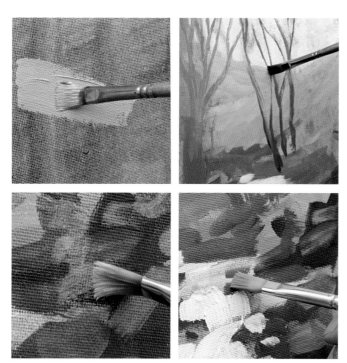
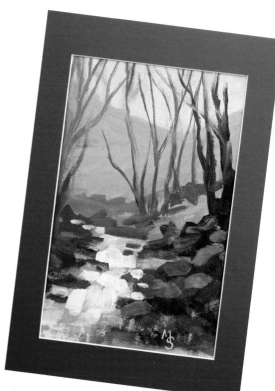

The main part of the book consists of practical projects for you to try. At the front of each project there is a further techniques section that will enable you to practise some of the things you will need to do when you come to work on the painting, or ways of painting a subject associated with the theme. If you do a bit of practice, you will enjoy the painting process more, so do not skip those bits!

As you work through the projects you will build each time on what you learned the session before. There are plenty of tips included, things I have picked up over the years that make painting easier and trouble free. These will help with anything from looking after brushes to displaying your finished work.

The main thing to keep in mind is that you should enjoy the process. Having fun sloshing paint around is what it is all about. It does not matter if you have not picked up a pencil since leaving school, or if you tried art once and gave up – you CAN learn to paint. I really believe that anyone can.

DISCOVER THE SUBJECT...

Each project covers a different subject to enable you to build up your range of skills.

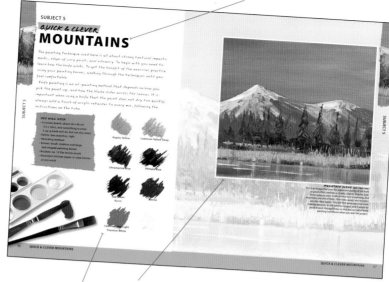

Colours used and materials needed are fully described.

The final project uses the range of techniques you will be exploring in this section

PRACTISE THE TECHNIQUES...

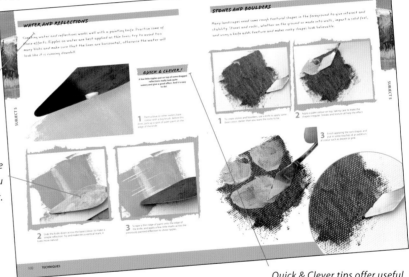

All the essential techniques are demonstrated to show you how to tackle the methods you will use in the project.

Clear instruction allows you to practise each technique step by step before you embark on the final project.

Quick & Clever tips offer useful advice throughout the book.

COMPLETE THE PAINTING...

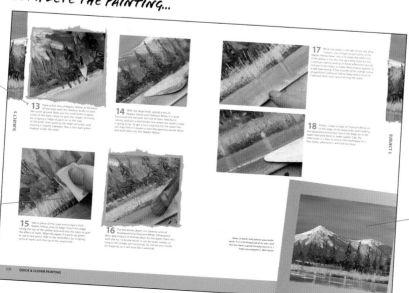

Each step of the project is clearly photographed and explained in the text.

Close-up photographs show how to apply brushstrokes and knife marks in detail.

Step by step, you will follow every stage of the painting right through to the finish

PAINT

Acrylic paint is available in two basic forms: liquid or heavy body. Liquid paint comes in jars, like ink, and heavier body paint in tubes like oil paint. I almost always use the tubes and dilute the paint with water if I want a more runny consistency. The advantage of tubes is that I can use the paint in a thicker consistency if I want to. If you use liquid acrylic you are limited to a thin application, but you might like to experiment with the inks as you gain confidence.

STARTING YOUR PALETTE...

All manufacturers have a large range of colours available, and most also have a reasonably priced starter set of tubes for beginners. The trouble with a small set, however, is that it may not contain some of the colours you need, and may have others that you will never use. It is better to choose your own colours, or get a starter pack and add to it.

QUICK & CLEVER!

If you look in an art shop or catalogue, you will find a bewildering array of colours to choose from but the good news is that you only need a handful to get going. Learn how a few colours can mix to make a lot more, rather than have too many and be confused.

This may look like quite a lot of gear, but you do not need to have everything to make a start. The most important thing is to buy a few good quality brushes and a few tubes of good quality paint. The rest, like easels and special palettes, can be purchased as you feel the need for them.

QUALITY COUNTS

We shall look at which colours to use shortly, but first a word of caution. There are many outlets that sell art materials, including stationers, booksellers, and market stalls, as well as art shops. Some of these retailers sell good quality paint, but others sell inferior products.

With paints, as with most things, you get what you pay for and you can buy a whole set of inferior paints for the same price as a few tubes of reasonable quality. Beginners often come to my classes and say proudly that they have bought their paints already. Then they produce a large wooden box full to the brim with little tubes, usually with no manufacturer's name or country on them. I dread this happening because I invariably have to tell them gently that they have wasted their money, and the box is probably worth more than the paint it contains.

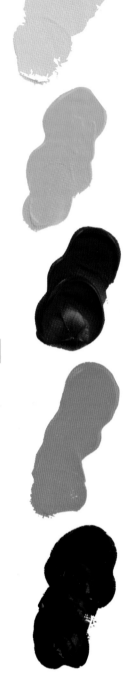

BUY THE BEST...

Cheap paint is made with inferior dyes rather than quality pigments and contains inert materials such as china clay to make it look better value than it really is. This means that you would be disappointed with your resulting paintings, and that is the last thing you want.

The moral is: buy a few tubes and the best you can afford. Art shops and art catalogues or magazines are the best places for choice and advice.

CHOOSING COLOURS

So, let us look at how to choose your colours, starting with the basics. Your palette should contain both a warm and a cool version of each of the three primary colours: these are red, yellow and blue. Do not worry too much about this colour terminology yet; we shall look at 'Colour' in more detail later on pages 20–23.

For the time being, I suggest a useful starter palette of colours would be Lemon Yellow, Cadmium Yellow Deep, Cadmium Red Light, Permanent Rose, Phthalo Blue and Ultramarine Blue. You will need Titanium White to make colours lighter. Get a large tube; you will use a lot, and it is more economical than buying several small tubes. Added to these seven paints are some yellows or browns called earth colours: Burnt Umber, Raw Sienna, and Burnt Sienna. Add a Naples Yellow, and a Sap Green, and that is it – a dozen colours. A small colour range is called a 'limited palette'; this is your first artistic term!

You will also develop favourite colours that you cannot do without; Naples Yellow is one of mine. This is all part of the process of developing a style, but for now stick to what I have suggested and try to resist buying every colour in the shop!

QUICK & CLEVER!

As you progress with your painting, you will discover subjects that appeal more than others, and these may well need a different colour range from the one I have suggested. For a flower painting, for example, you may need more reds, yellows and oranges than for painting seascapes.

MATERIALS

MIXING PALETTES

There are basically two types of acrylic technique – transparent and opaque – and each needs a different kind of palette. If you are using the paint diluted, in the transparent, watercolour way, it will not dry out on the palette because it will be in puddles of water. Use watercolour palettes with separate wells for this technique. Some artists use the trays you can get for baking buns; do not use them for both jobs!

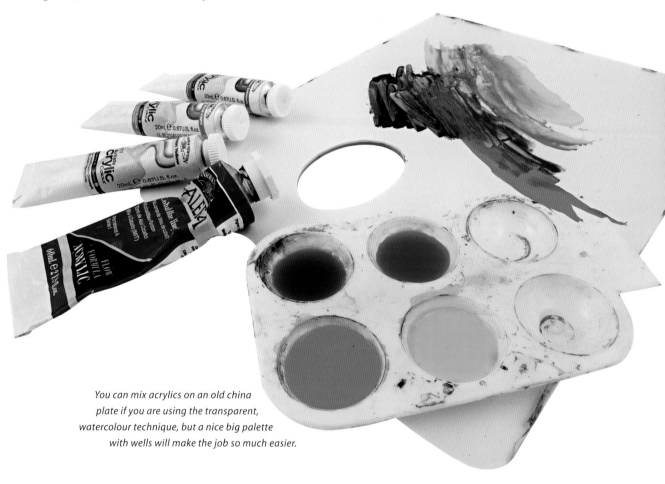

You can mix acrylics on an old china plate if you are using the transparent, watercolour technique, but a nice big palette with wells will make the job so much easier.

STAY-WET PALETTES...

When mixing acrylic colours like an oil painter would, on an oils-type palette, you will find that the paints dry fairly quickly. In order to avoid this happening, if you are using the opaque, oils technique it is best to use a special acrylic 'stay wet' palette.

A stay-wet palette consists of a plastic tray that contains an absorbent paper covered with a membrane, on which the paint is mixed. You simply wet the underlayer, place the membrane paper on top, and squeeze the paint onto it. When you have finished painting, cover the tray with its lid, and the paint stays workable. I have kept acrylic paint in one of these for over twenty days without it drying! You can make do with a couple of discs of wet blotting paper on a large plate, covered with a disc of greaseproof paper. When you have finished painting, cover the plate with some plastic and it will keep your paint moist for a short time.

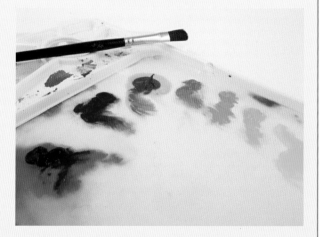

The easy way to stop paint drying out is to invest in a special acrylic palette; it will save you money because you will not be throwing dry paint away, and it will enable you to keep a particular mixed colour until you are ready to use it. Always follow the manufacturer's instructions.

EASELS

You can manage without an easel if you are always going to be painting indoors. Even then, however, a table easel is a good investment, especially if you are using acrylics like oils, when you need a more vertical position for the board.

Get a sketching easel if you are intending to venture outdoors. A good painting position means you will avoid developing backache, and you will enjoy your art more.

MEDIUMS

Mediums are added to paint to dilute it or change its consistency. The simplest medium of all for acrylics is water! If you want to paint like a watercolourist, this may be all you need. However, there is a medium that helps the flow in a watercolour method, called flow improver, which I find useful. You add a few drops to water.

GLAZING
Most other mediums are used to impart a particular property to the paint. Use gloss or matt painting mediums if you want to paint in transparent layers on top of dry underpainting. This is useful if you want to paint shadows on later, or want to change the colour of something. These are sometimes called glazing mediums.

TEXTURE
There are mediums that change the texture of the paint. These come in a variety of effects: sand, beads, fine or heavy paste, and more. If you want to have lots of texture in your work, give these a try.

RETARDERS
Finally, and importantly, there are mediums that are 'retarders', which slow down the drying time. These are useful for blending and other techniques where you do not want the paint to dry too fast. For mixing ratios and other information, always read the label.

MEDIUMS YOU WILL NEED . . .

Now for the good news! All you will need to paint the projects in this book is an acrylic matt medium, and a retarding medium. I have used a flow improver in the watercolour techniques; it is not essential, but makes painting easier.

QUICK & CLEVER!

Always make sure that you replace the lids on jars of mediums as soon as possible. Never leave them open to dip into; they will dry out and be useless. To avoid lids getting stuck and difficult to open, wipe the tops and edges of jars with wet kitchen roll before replacing.

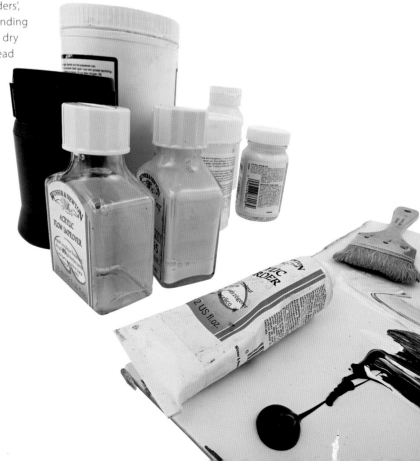

BRUSHES

Brushes and knives are the contact between you and your work. You need to build confidence in your brushes, learn what each shape can do, and how to make your brushstrokes build into a painting. They are an investment; you will never regret buying a good quality brush. You do not need many brushes, so buy a few good ones and avoid the very cheap sets.

MAGIC NUMBERS...

The sizes are numbered, with higher numbers denoting larger sizes. Your choice will depend upon what size you want to work; someone who paints tiny miniatures will need a different set from a mural painter. My brushes range from a basic household paintbrush to more specialist paintbrushes, but I only regularly use a half dozen or so.

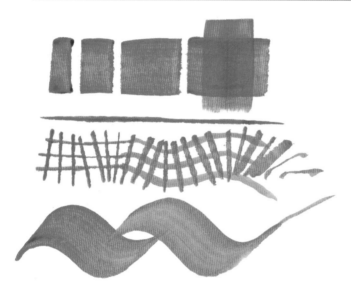

Marks made with round synthetic bristle brushes.

Pressing harder makes thicker lines.
A bigger brush can make a longer stroke.

All these marks were made with a 12mm (½in) synthetic sable brush.

Thin lines can be made with the point of a synthetic sable.

A flat brush gives a hard edge.

QUICK & CLEVER!

It is always a good idea to have a couple of household-type paintbrushes for large areas and for priming boards. Keep these separate and for artistic use only; you do not want your masterpiece contaminated by the undercoat from painting the wall!

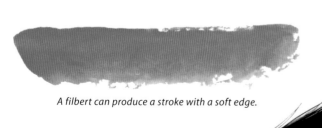

A filbert can produce a stroke with a soft edge.

BRUSHES FOR ACRYLICS

There are brushes specially designed for use with acrylic paint; each manufacturer has a range. As with paints, buy just a few, and learn how to use and look after them properly. There are two distinct types: those for use with an oil-painting technique, and those for using with a watercolour method. Get a few of each, so you can work through all the sections in the book with the right equipment. All the brushes used in this book are either synthetic sable, in the case of watercolour types, or synthetic bristle for oils.

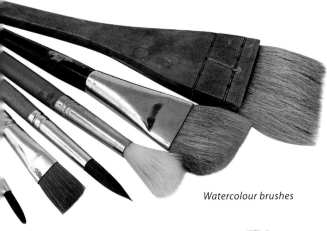

Watercolour brushes

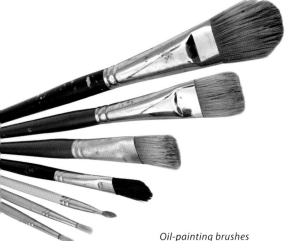

Oil-painting brushes

WATERCOLOUR TECHNIQUE BRUSHES

Watercolour-type brushes are mainly round, with short handles. Avoid expensive sable brushes for use with acrylics; synthetic sable does the job just as well and is less than half the price. Sizes 2, 6 and 10 should be enough, with a 12mm (½in) flat brush for angular shapes such as windows, and a 25mm (1in) flat brush for applying washes.

An oriental brush known as a hake is also useful. Hake brushes are made of goat hair or similar and are quite cheap. I use 25mm (1in) and 50mm (2in) hake brushes for washes.

Make sure that you clean your brushes thoroughly with soap and water. I use hair shampoo on most of my brushes every so often and none of them have dandruff.

OIL-PAINTING TECHNIQUE BRUSHES

Oil-type brushes come in three basic shapes: round, which comes almost to a point; flat, which is square ended; and filbert, which is a flat brush that comes towards a pointed tip. As a general guide I would suggest you have a no. 6 round, nos 6, 10 and 12 flat, and a no.10 filbert. A fan blender, for blending colours on the painting, is useful, too. If you want to spend less money, just buy the flat ones to start with.

There are some very good synthetic bristle brushes on the market; they hold their shape and last well. Real hog hair quickly goes out of shape if you are not careful. Light applications of opaque paint can be made quite well with the watercolour types too, but you will not achieve the same textural marks that you can obtain with bristle brushes.

BRUSH CARE...

The main point to remember when using your brushes is never to let paint dry in the bristles or hair. If you do, it is almost impossible to get the brush back to how it was before. It must become a habit for you to put brushes in water when not in use.

As soon as you have finished with a brush, even if you are going to use it again in a few minutes, pop it into a jar of water if it is a bristle type, or lay it on its side in a shallow dish filled with water if it is a watercolour type. If you leave synthetic sable brushes with their points resting on the bottom of a water jar they quickly lose their points and get scruffy. When you want to use the brush again wipe excess water off first.

Before putting a brush away, clean it by rinsing it thoroughly in a jar of water, and then 'paint' on to a block of household soap. Then work the bristles back and forth by using a painting motion in the palm of your hand. Make sure that all the pigment is removed, especially where the hair meets the ferrule (the metal bit of the brush).

Store brushes (hairs up) in a jar, or upright in a brush tube. Never leave brushes squashed or misshapen; they could stay that way.

PAINTING KNIVES

A painting knife is a good tool to have. It is used for the technique known as 'palette knife painting' and may also be used for mixing paint. The best ones are made of stainless steel and will last for a lifetime. Painting knives are available in a range of shapes and sizes, with each manufacturer providing them singly or in sets of three or more.

SHARP DETAILS...

I like to have three leaf-shaped knives, a large, medium and small, and often use them in a painting, for applying or scraping off. Make sure you get ones that have a bend between the handle and blade, so that your knuckles do not touch your painting as you work.

QUICK & CLEVER!

Be careful with painting knives. They are not particularly sharp when purchased, but can become sharper with use. You may have to rub the edge on a piece of sandpaper every so often to blunt it. Do not cut yourself!

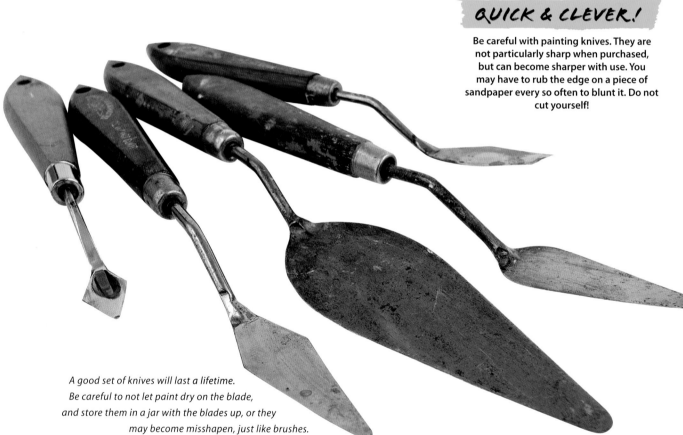

A good set of knives will last a lifetime.
Be careful to not let paint dry on the blade,
and store them in a jar with the blades up, or they
may become misshapen, just like brushes.

KNIFE CARE...

Wipe knives clean on a rag or absorbent kitchen paper as soon as you have finished with them or they could start to rust underneath the dry paint layer.

It is best to store your knives wrapped in a piece of cloth so that they do not get damaged.

OTHER TOOLS

A collection of scrapers is useful. Collect pieces of plastic such as food containers, or pieces of card, and cut them with heavyweight scissors to make your own designs of scrapers. Use these for moving wet paint around on the board, scraping back to show the underneath colour, and making textural marks.

Sponges are also useful tools. They can be used for stippling, producing foliage and tree effects, applying liquid paint, and adding texture to foregrounds. Natural ones are best, but synthetic sponges can be torn or cut to produce interesting marks.

USEFUL EXTRAS . . .

In addition you will find masking tape and clips useful, a hair drier and scissors handy, and tatty old brushes useful for spattering.

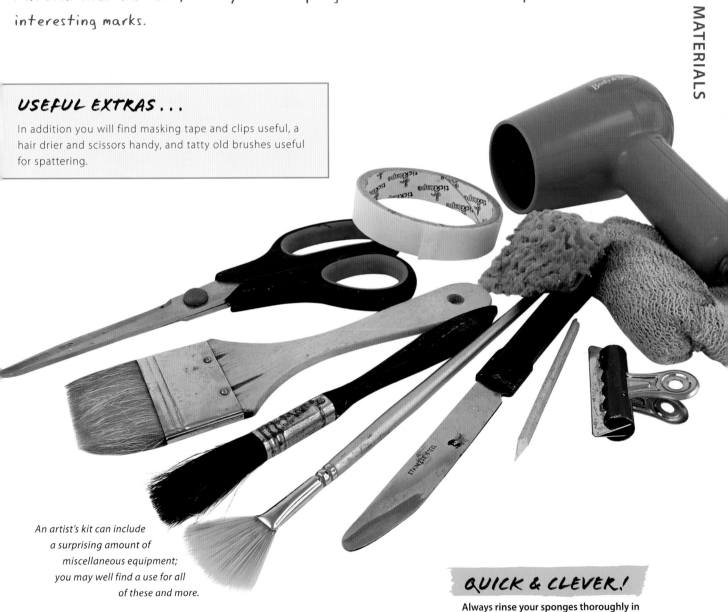

An artist's kit can include a surprising amount of miscellaneous equipment; you may well find a use for all of these and more.

QUICK & CLEVER!

Always rinse your sponges thoroughly in warm water when you have finished using them. During use you can stop sponges drying out by keeping them wrapped in a small polythene bag.

SUPPORTS

Another bonus with acrylics is that you can paint on any surface that is not shiny or oily. If you are using a traditional watercolour method, then the best surface is paper made for the purpose. If you are looking to save a bit of money, and do not mind if your painting does not look like a watercolour, then you can work on almost anything: brown paper (not the shiny side), wallpaper, lining paper, cardboard, mount board, interior quality hardboard or plywood.

WATERCOLOUR PAPER

Watercolour paper comes in various size pads of ten or so sheets, blocks (where the edges are glued down), or in single large sheets. It comes in various thicknesses, usually expressed as a weight: the higher the number, the thicker the paper.

Some paintings will call for you to apply a thin wash of colour. Therefore it's important to use the correct paper to avoid it buckling during this process.

WEIGHTY MATTERS...
Throughout this book, where I have used watercolour paper, it is 420gsm (200lb) in weight. This is medium heavy, so the painting will not buckle or cockle as you work, and does not need glueing down, or stretching.

SKETCHBOOK SECRETS...

A sketchbook is a kind of visual diary. Getting into the habit of carrying a small book with you, and drawing in it whenever you get the chance, is a very good way of improving your drawing skills. No one needs to see the drawings if you do not want to show them, just as no one needs to see your diary.

CANVAS CHOICE...

If you want your work to look like an oil painting, canvas boards are quite good. They are real canvas stuck on to a piece of board and primed. You can get various sizes, and trim them with a craft knife if you wish; the canvas will not peel back. When you are more proficient you may like to try stretched canvas, but canvas is a bit expensive to begin with. You can paint straight on to any of these non-shiny, non-oily surfaces, but it is best to prime them with a gesso primer.

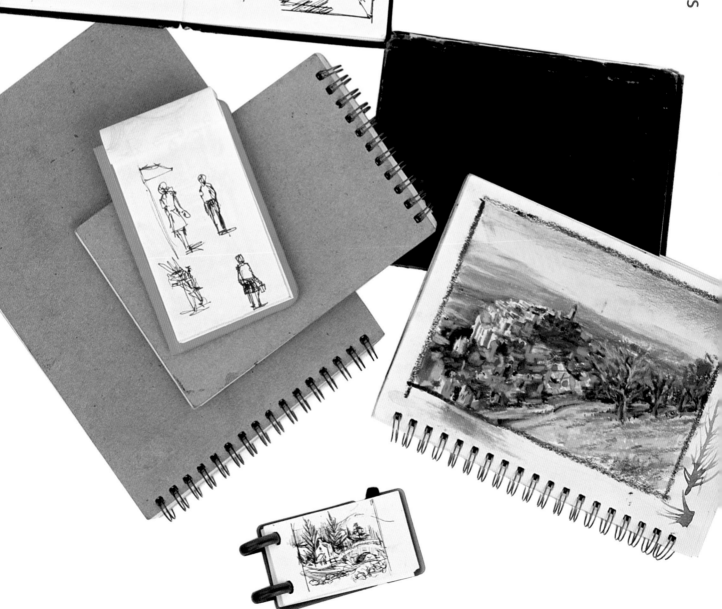

PRIMING

Any non—shiny surface can be used with acrylics. Sometimes it is necessary to use a white board, or one of a particular colour as a base for your painting, and a heavy primer called a gesso is used for this; make sure you use an acrylic gesso. Gesso comes in a small range of colours, usually white, black, brown and clear. Don't forget, clean all brushes with water as soon as you have finished.

1 Any acrylic colour can be added to gesso to tint it. To prime a board for painting, pour some gesso into a container such as an enamel plate, add some of the required colour for tinting and mix well.

2 Use a soft household paintbrush or varnish brush to apply one coat of the gesso, undiluted, or very slightly diluted with water. Keep the brushstrokes going in one direction.

QUICK & CLEVER!

If the board is thin, to avoid warping, apply two diagonal strips of wide masking tape to the back of the board, corner to corner, before starting to apply the gesso.

3 When the surface is dry, apply another coat, with the brushstrokes going across the direction of the first coat.

OTHER SUPPORTS

Acrylic paint is so versatile that it is widely used to decorate wooden furniture and such; make sure that the wood is dry, unvarnished, and free from knot holes. To stain the wood for a background effect, use a colour of your choice and dilute it with water to make a stain. Test for strength on a piece of scrap before applying.

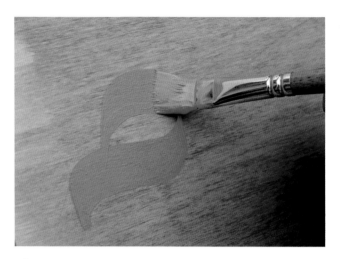

1 Put the stain on with a soft household paintbrush and leave to dry. This may raise the grain on the wood slightly, so a gentle rub over with fine sandpaper may be needed. Then draw out your design with a soft pencil.

2 Paint the design with the same brushes that you would use for painting a picture. 12mm (½in) and 25mm (1in) flat brushes are excellent for this sort of painting. Use paint that is only diluted enough to make it flow, not too thin.

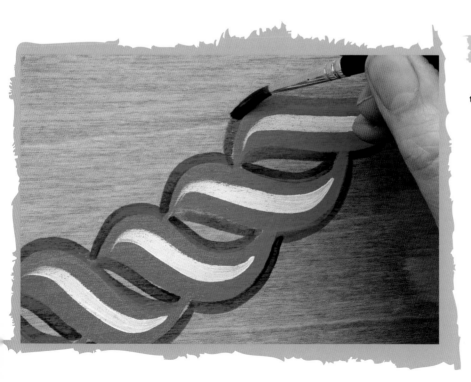

QUICK & CLEVER!

Another good support for working is muslin or cheesecloth. This is very finely textured, and slightly diluted paint applied with a round watercolour brush in the oriental style looks good. To paint light fabric it may help to stretch it first on a frame. This is ideal for making screens or decorating lampshades!

3 You may find the addition of a touch of acrylic retarder makes the job easier when painting finer lines and shapes. This will give you more working time.

PRIMARY COLOURS

There are three primary colours — red, yellow, and blue — and, in theory, all other colours can be made from these three. But colour, like life, is not so simple! You need a different version of each primary, and in choosing these colours you need to consider the 'temperature' of each colour.

COLOUR TEMPERATURE

Colour has an important property that we need to be aware of, and that is temperature. Warm colours, such as reds, browns, oranges and some yellows, appear nearer than cool colours such as greens, blues and violets, which appear further away. So if you paint a distant hill a red-brown colour, it may not look very far away at all, and spoil the effect of your painting.

COOL OR WARM

Look at the yellows shown here; one is nearer to orange than the other one. The orange-yellow is the warm one; it has some red in it.

Look at the two reds. The dark one looks nearer to violet than the other; it is a cold red. I am sure you get the idea. In a mix, the cold red will make a better violet when mixed with a cool blue, and the warm yellow will make a good orange if mixed with a warm red.

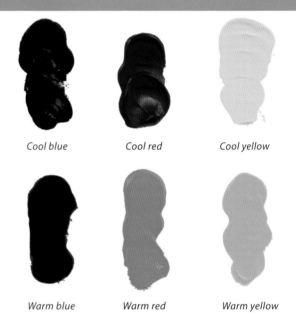

Cool blue Cool red Cool yellow

Warm blue Warm red Warm yellow

THE COLOUR WHEEL

A good way of getting used to using paint is to make a colour wheel like these. It not only teaches you how colours mix, but gives you good practice at handling the paint itself, without worrying about doing a painting. Colour wheels have been used for centuries by artists, to try out different combinations. These colour wheels show how warm and cold colours fit together to make a circular rainbow. See how you can make quite a range of colours from just six primaries!

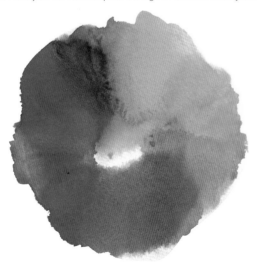

Acrylic paint diluted with water in the transparent method.

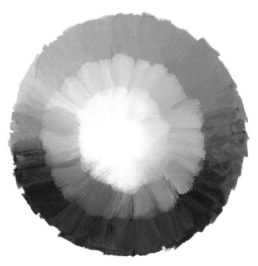

Undiluted opaque paint, with white added on the inner circle to make it paler.

SECONDARY COLOURS

When two primary colours are mixed together they produce the secondary colours orange (from red and yellow), violet (from red and blue) and green (from blue and yellow). Here the primaries are laid out in a triangle.

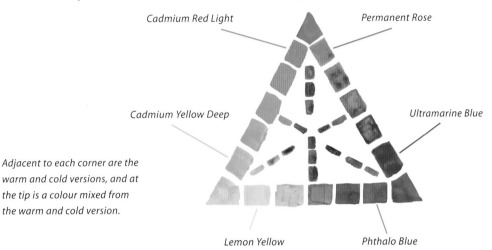

Cadmium Red Light

Permanent Rose

Cadmium Yellow Deep

Ultramarine Blue

Adjacent to each corner are the warm and cold versions, and at the tip is a colour mixed from the warm and cold version.

Lemon Yellow

Phthalo Blue

COMPLEMENTARY COLOURS

Colours that are more or less opposite to each other on the colour wheel are called complementaries. For several centuries artists have recognized that certain colours 'go' together. You can plan your work in such a way that these colours appear close to each other in a painting; red and green, yellow and violet, blue and orange.

To get the best effect, there should be more of one colour than its complementary, and the colour that covers the largest area should be less vibrant. So a painting of a woodland, with lots of dull greens, could have a red roof in amongst the trees, or a figure with a red coat. Great artists like Constable, Pissarro and Monet all used this 'complementary colour scheme' to good effect, and it is worth keeping in mind when you choose colours for a painting.

MIXING COMPLEMENTARIES...

The little rectangles painted inside the triangle show what happens to a colour if you mix its opposite (complementary) with it. So blue, when mixed with its complementary, orange, becomes grey, while yellow mixed with violet, and red with green, results in browns. This is useful when deciding what colours to put where, as well as mixing. A green landscape needs a touch of red; a blue seascape looks good with an orange sail, and so on.

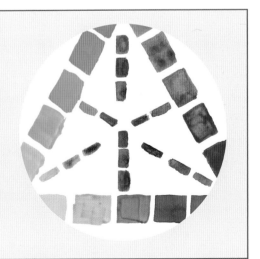

COMBINING COLOURS

Choosing a range of colours in a painting is called colour composition. The colours will impart a mood or atmosphere to the image. You will find as you gain experience that certain combinations of colours appear more attractive than others. This appreciation of colours varies from person to person, and there is no right or wrong as far as colour is concerned. Experiment and use the colours that work for you.

MOOD AND ATMOSPHERE

The main point to consider is, 'does my painting impart the kind of atmosphere I want it to?' The two images shown on these pages have a very different 'feel'. The portrayal of atmosphere in a painting is something you should strive for. As you gain experience you will be able to adjust colours without thinking too much, but while you are learning you need to consider the range that you are going to use. In the projects that come later in the book I have chosen colours for you, but you will still have to mix them and see how they look on the painting. The beauty of acrylics is that colours are very easy to change, and so, if a colour appears too dominant, or looks out of place when compared to the rest of the image, you can either put a glaze over it, or re-paint it in a more suitable hue.

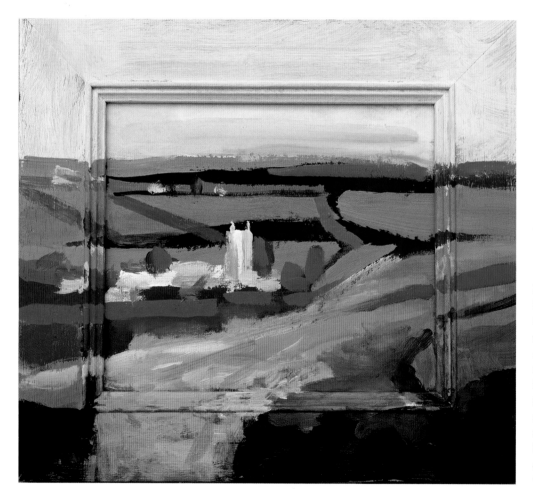

This painting is very bright, with a strong use of complementary colour, mainly orange and blue. It looks strong and sunny; it is optimistic in mood because of the way the colours are applied, adjacent to each other. There is very little grey or brown, the so-called 'neutral' colours.

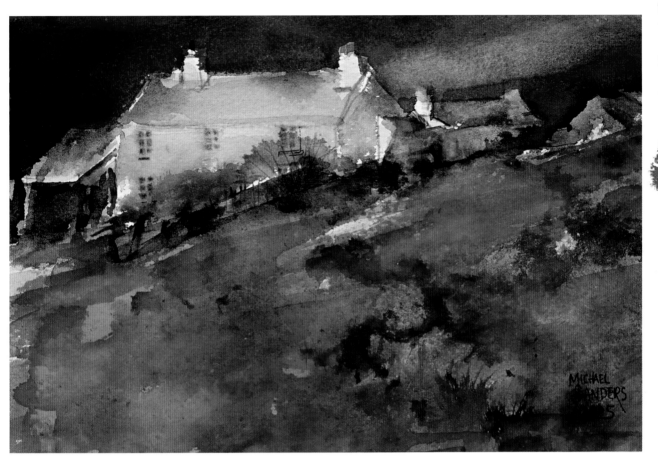

Now consider this painting, which uses a subdued range of colours, including greys and browns; it is much darker and evocative of a still, quiet evening. The sky is deep violet, and although the orange is still there, it is more subdued. They are both correct images, because they convey what I intended.

QUICK & CLEVER!

Choosing colours sensitively will come with practice. Enhance your knowledge of how colour works by visiting galleries and examining other artists' work whenever you can. Try to figure out why they chose a particular range of colours.

23

TONE

We have looked at colours; now we need to consider 'tone'. Some people find the term 'tone' confusing, but it is really quite simple. Imagine you are looking at a black and white photograph. What do you see? Certainly not colour. Yet the photograph is perfectly understandable. Why is this? Because parts of the image are darker, or lighter, than their surroundings, so they stand out. This is called 'contrast', and the varying amount of contrast in an image is known as 'tonal values'.

Artists need to be able to look at a colour, and see where it comes on a tonal scale. To help you do this, it is worth making a 'grey scale'.

MAKING A GREY SCALE

Mix a very dark colour using undiluted Ultramarine Blue and Burnt Sienna. Put some white out, and add just a tiny touch of the dark colour to the white, to make a very pale grey. Paint a postage-stamp size square of this colour on a piece of paper. Next, add a touch more of the dark colour to give a mid light grey, and paint another square beside the first one. Then mix a little more of the dark colour, paint a darker square, and so on, until you end up with the darkest colour at the end.

If you find you have a sudden jump in tone, adjust the colour by adding white (if it is too dark) and overpainting the square before continuing with the next one. You should end up with six or seven clearly separate shades of grey. Now use this grey scale to compare the relative tones.

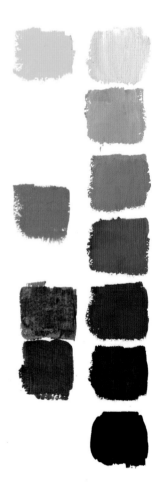

It is good practice to try placing colours where they should come on the grey scale. Can you see that the blue is darker than the green? What about the red and the yellow?

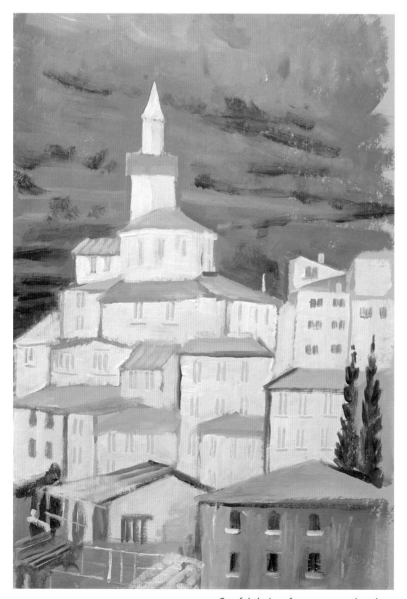

Careful choice of tone ensures that the buildings stand out against the darker background.

TWO WAYS TO MAKE A COLOUR PALER

There are two entirely different ways to work with acrylic paints; that is what makes them so exciting! One is transparent, the other opaque.

You can combine the transparent and opaque methods in the same painting, which is very useful if you make a mistake; simply switch to opaque and paint it out!

TRANSPARENT METHOD

With the transparent method the colour is made progressively paler by gradually adding water to the mix.

The way to do it is to make a puddle of paint in the watercolour palette, and start with a brushstroke across the top. Then, working quickly, add a few drops of water to the puddle, and paint another strip, overlapping the last one slightly. Continue in this way down the paper, adding water as you go. As the lower area has less pigment and more water, more of the white paper shows through.

OPAQUE METHOD

The opaque method uses a different way of lightening the colour. The starting colour is made paler by gradually adding Titanium White.

The way to do it is to mix a pale colour, such as a pale blue made from Ultramarine Blue and white, on a stay-wet acrylic palette, and paint a strip across the top of the image. Add a touch more white and paint another strip, and so on, adding a touch more white each time. Then before it dries, use a fan blender brush to smooth some of the texture away. It may be easier to use a touch of retarding medium with this method, to slow the paint down slightly.

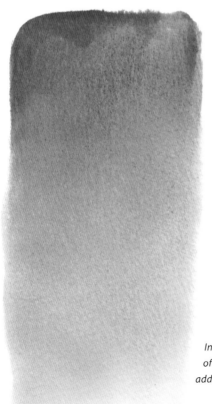

In the transparent method of making a colour paler, add water.

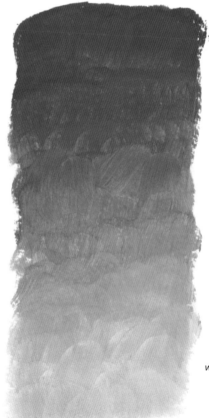

In the opaque method of lightening a colour, white is added.

25

MAKING SUBTLE COLOURS

Acrylics used to have a reputation for being bright and garish, and maybe in the early days there was a certain false quality about the colour. The modern acrylic paint has none of these problems, however, and you can achieve very subtle colours with them. But it takes practice!

Most of the colours can be made less bright, or 'subdued' to use the correct term, by adding a brown to them. These browns, called earth colours because that is where they are sourced from, are very useful modifiers. Burnt Umber, Burnt Sienna and Raw Sienna are good colours to have in your palette.

SUBDUING COLOURS...

If you feel the need to subdue a colour, it helps to have a scrap of paper to try out the results of adding an earth colour or complementary. You should wait for this trial colour to dry before deciding if it is suitable, as it may darken slightly as it dries. Add an additional colour a tiny touch at a time so you can control the effect more easily. Bright reds will deepen slightly and become dull if you add a brown such as Burnt Sienna, greens will become warmer and darker, blues will go slightly grey.

QUICK & CLEVER!

Another method of subduing a colour is to add a little of its complementary, a method favoured by the French Impressionist painters of the nineteenth century. Work through some of the examples shown here, for practice.

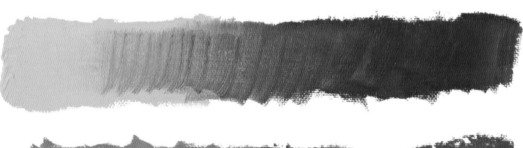

Adding violet to yellow wi[ll] cause it to turn dull, an[d] eventually brown will resul[t]

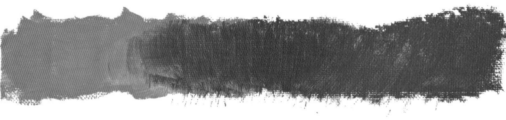

Blue can be made less brigh[t] and will become grey, whe[n] orange is adde[d]

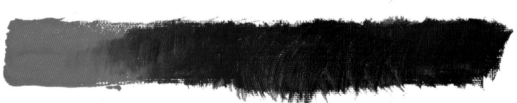

Red can be 'toned down', o[r] subdued by the addition o[f] green and vice vers[a]

Ultramarine Blue

*Ultramarine and
Burnt Sienna*

*Ultramarine and
Burnt Umber*

*Ultramarine and
Cadmium Red Light*

Cadmium Red Light

*Cadmium Red Light
and Sap Green*

*Cadmium Red Light and
Phthalo Blue*

*Cadmium Red Light and
Burnt Umber*

Cadmium Yellow Deep

*Cadmium Yellow Deep and
Raw Sienna*

*Cadmium Yellow Deep and
Burnt Sienna*

*Cadmium Yellow Deep
and Burnt Umber*

Cadmium Orange

*Cadmium Orange and
Burnt Sienna*

*Cadmium Orange and
Ultramarine*

*Cadmium Orange and
Phthalo Blue*

COLOUR

MAKING LANDSCAPE GREENS

Greens always present problems for artists, however experienced they are. Most beginners will attempt to use a green straight from the tube and be disappointed with the result, because the effect is always too bright and garish.

All landscape greens need to be modified by the addition of other colours, as real natural greens have browns, reds and even oranges in them. Most of the earth colours work well when mixed in, and Naples Yellow is useful for lightening a green if using the opaque method.

MIXING GREENS

To start with it is a good idea to have a basic green and add colours to modify it. Sap Green is a dark mid green that works well with earth colours, yellows, reds and oranges to produce a fairly wide natural-looking range. Naples Yellow or Lemon Yellow mixed with a little Sap Green makes a light spring green.

To practise making greens, mix three or four little puddles of diluted Sap Green in a watercolour palette. Then dilute some Raw Sienna, Burnt Sienna, Lemon Yellow and Burnt Umber. Add these to the green a touch at a time, and try out the results on a piece of scrap paper. When you are happy with the results, paint a rectangle on some watercolour paper to keep as a reference.

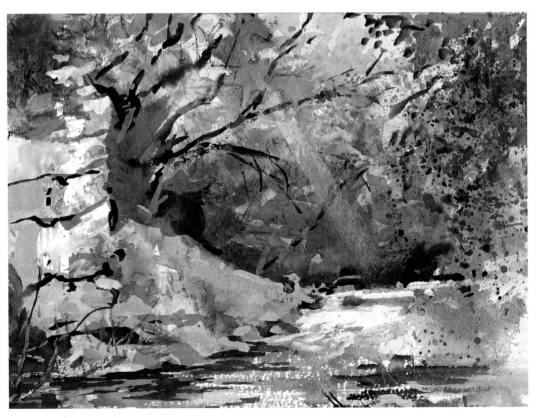

A large range of natural-looking greens can be made from a few basic colours. It is worth practising mixing the greens shown on page 29, especially the darker ones.

GREENS BASED ON SAP GREEN

Sap Green

Sap Green and Raw Sienna

Sap Green and Cadmium Yellow Deep

Sap Green and Burnt Sienna

Sap Green and Lemon Yellow

Sap Green and Cadmium Orange

Sap Green and Naples Yellow

Sap Green and Cadmium Red Light

Sap Green and Ultramarine

Sap Green and Phthalo Blue

Sap Green and Cerulean

Sap Green and Burnt Umber

MIXED GREENS

Here are some green mixes that I use regularly in my landscapes.

Phthalo Blue and Lemon Yellow

Phthalo Blue and Cadmium Yellow Deep

Phthalo Blue and Raw Sienna

Phthalo Blue, Lemon Yellow and Burnt Sienna

Ultramarine and Lemon Yellow

Ultramarine and Cadmium Yellow Deep

Ultramarine and Raw Sienna

Ultramarine, Lemon Yellow and Burnt Sienna

TRANSPARENT TECHNIQUES

THE TRANSPARENT METHOD OF PAINTING WITH ACRYLICS USES THE WHITE OF THE PAPER FOR LIGHT AND WHITE AREAS. BY DILUTING THE PAINT, AND MAKING IT MORE TRANSPARENT, COLOURS CAN BE MADE TO LOOK PALER.

WASHES

A watery, liquid application of paint is called a wash, and forms the basis of the transparent technique.

By putting less water in the mix, colours will appear darker and more intense. If you have ever done any watercolour painting this will be familiar to you.

The difference between acrylics and watercolours, though, is that, when dry, the acrylic wash will not be lifted or moved by subsequent layers, so the colours remain vibrant. To get the best from this method, use good quality watercolour paper.

Speed of application is important when applying a wash, and it is best to have the paper at a slight angle, preferably taped to a board. Use a large brush, working from side to side, and overlap each stroke by about half a brush width to avoid streaks.

QUICK & CLEVER!

Personally I prefer 425gsm (200lb) paper that has a rough texture, as this allows the colours in washes to separate and produce a speckled effect.

FLAT WASH

A flat wash is best applied with a large brush like a hake, or a 25mm (1in) flat brush. It goes on best on paper that has been pre-wetted. Timing is important; if you wait too long after wetting the paper, it will start to dry, but if you put paint on immediately you may get dribbles or puddles on the paper. The right time is when the shine has just gone off the paper, but before it goes back to being matt; look against the light to tell.

VARIEGATED WASH

By using a rough, heavily textured watercolour paper, colours will often separate, to form interesting speckled effects, known as granulation. Ultramarine Blue and Burnt Sienna will often do this, but the effect depends on the dilution, so you will need to experiment with different amounts of water.

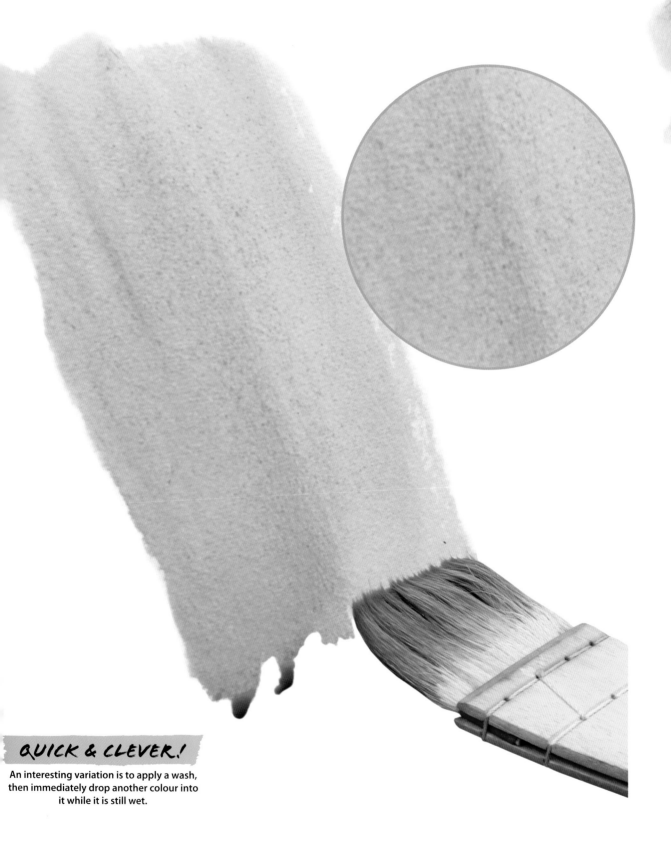

QUICK & CLEVER!

An interesting variation is to apply a wash, then immediately drop another colour into it while it is still wet.

GRADUATED WASH

When you have had some practice at single colour washes, the next step is to progress to graduated washes. This is a classic watercolour technique, where two or more colours are applied, starting with a single colour, then progressively adding amounts of another colour so there is an even, almost imperceptible change from one colour to the other. This technique needs plenty of practice and is not easy, but being able to paint effects such as a sunset make it worth practising and mastering.

HOW TO A APPLY A GRADUATED WASH . . .

It is best to have the colours in a palette with large wells, already diluted, so that when you begin painting you will not have to stop and adjust. Start with one colour, wash a couple of strokes across, then pick a little of the other colour up and mix the two together in the palette in an empty well. Paint this colour on, pick a little more of the other colour up and apply, and so on. Skies are particularly attractive painted this way, and distant parts of a landscape work well using a graduated wash.

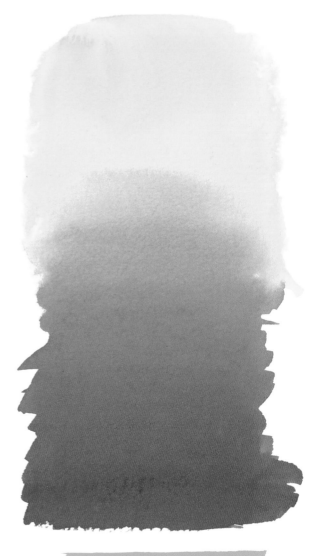

It is worth practising this technique on watercolour paper, especially for dramatic skies. If the end result is not what you hoped for, keep the paper; you can use it for an opaque painting, or turn it upside down and paint a landscape over it.

QUICK & CLEVER!

It sometimes helps the colour to blend if the paper is pre-wetted and a touch of flow improver is added to the water before you start.

WET-ON-DRY

This is an easy method to use, compared to a wash, as there is not such a rush to get paint on before things start to dry. It is simply a colour placed on top of a dry layer, or on dry paper. With a wet—on—dry technique, you will always get a hard edge, and this can be utilized to good effect if you make the brushstrokes follow the shape or contour of the subject you are painting.

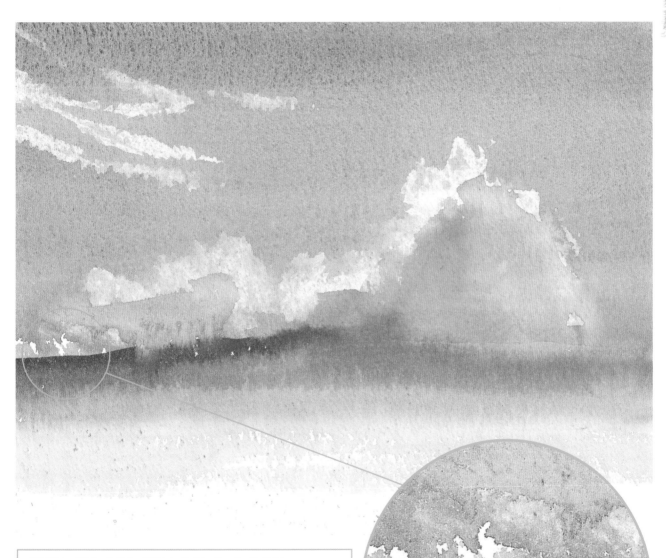

HOW TO PAINT WET-ON-DRY...

Wet-on-dry is the simplest way to paint, because there is no need to work fast, but you must bear in mind that your brushstrokes will have a hard edge. Layering one stroke over the next will produce interesting effects where the dry edges overlap, but you need to be careful where you use a dry edge; portraits, for instance, do not work well with too many hard edges.

You can clearly see the difference between a wet edge and a dry one.

WET-IN-WET

This is a classic watercolour technique that lets the acrylic glow, when painted on to watercolour paper. Because acrylics are not lifted or washed off like watercolours would be, it is possible to build up a painting using one wash on top of another without the image going muddy. Basically, there are two ways of doing it.

WORKING ON DRY PAPER

The first way of working wet-in-wet is to use dry paper, applying paint of various colours and letting them blend on the surface of the paper. This gives spontaneous and unpredictable results, which is part of the excitement!

Here, using dry paper, I have dropped green into a blue, which has blended and run. While still wet, I have dropped some yellow in. To do this, mix your dilute colours in advance; if you have to mix as you go, the painting will dry. Add a touch of flow improver to the mixing water. Drop colour in by either touching a loaded brush to the painting, or squeezing some paint from the brush with your fingers.

WORKING ON WET PAPER

This is an entirely different effect. First, the colours are diluted to the correct amount in the watercolour palette. The paper is pre-wetted, with a touch of flow improver added to the water. Then the colours are put on with a delicate touch. The paint flows softly into other colours, and gives a gentle, soft-focus look.

QUICK & CLEVER!

This type of practice piece is handy for future reference. Also, the more you experiment with colour mixing the better you will get.

To paint a soft colour wheel like this is good practice for trying wet-in-wet on wetted paper. Get all the colours diluted and ready. Wet the paper. Start by applying the Lemon Yellow; it is the palest colour, and the one most easily contaminated by other colours, so it helps to get it on first. Then work clockwise round, using the colours from the colour triangle.

DRY BRUSH

Dry brush is a useful way of putting sparkle on water, or giving the impression of foliage. The technique works best if you use a large brush (the hake is best).

HOW TO APPLY DRY BRUSH...
Take up some of the paint with the brush, then remove a little of the paint by touching the brush on a tissue. This almost dry brush is then dragged across the paper, with hardly any pressure other than the weight of the brush.

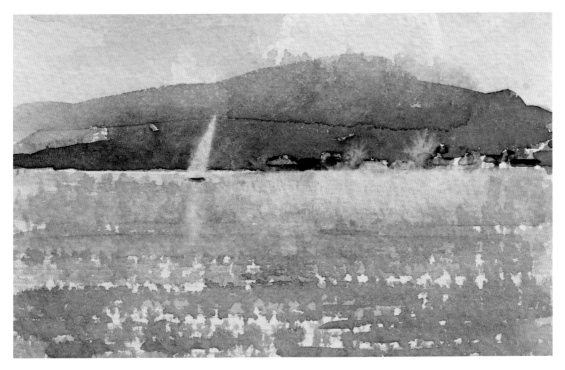

It is important, when using the dry brush technique, to touch the brush gently on the surface of the paper. Using the side, rather than the tip of the brush, may give best results. Too much pressure and the effect will be lost.

QUICK & CLEVER!

Rough paper gives the best results. The paint is literally dragged off by the troughs in the rough surface, giving a speckled look that is most effective.

35

GLAZING

Glazing is a technique that enables you to put a colour on to a painting without obliterating the colour underneath. Because it does not lift the underlayer, as it would in watercolour, it is very useful for adjusting colours and tones. It is possible with a glaze to build up layers of colours to give more colours; a yellow glaze put on to a blue layer will give you a green, for instance.

BEFORE YOU START...

You need a matt medium, sometimes called a glazing medium. Put small amounts of paint into this, on an acrylic stay-wet palette, and test until you obtain the desired strength of colour.

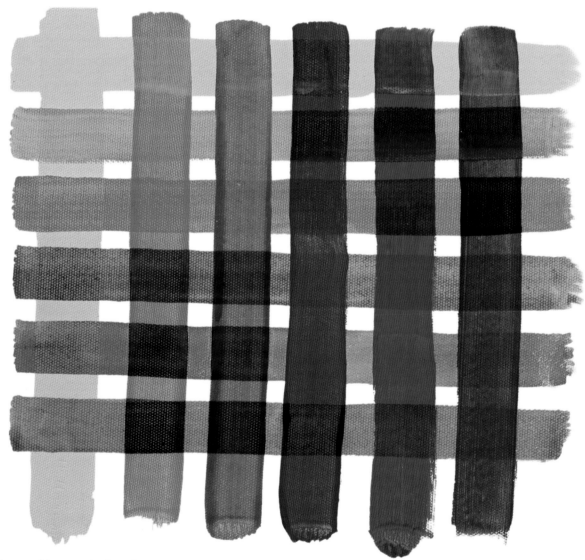

Glazes work best on a bright surface. Try using glazes on watercolour paper, or on a painting that contains a lot of light areas. The eventual colour will inevitably be darker if a glaze is applied.

LIFTING OUT

Removing paint by using absorbent kitchen paper is another traditional watercolour technique. It has to be done quickly, or the paint film will start to dry.

HOW TO LIFT OUT...

The absorbent paper should be slightly damp, and turned over so a fresh piece is used each time, otherwise you are simply putting the paint back on again!

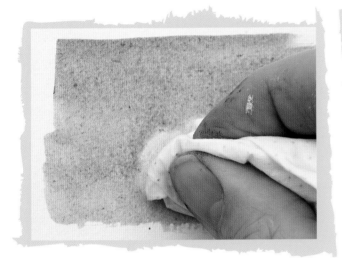

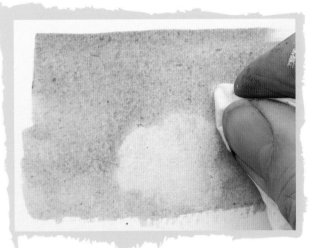

1 You need to have absorbent kitchen paper ready. Apply a blue wash to the painting paper. Then, as soon as you can, use a wad of absorbent paper and touch the surface of the painting.

2 Absorb some of the paint to make a cloud shape. Turn the absorbent kitchen paper over to a fresh piece and make some more cloud shapes.

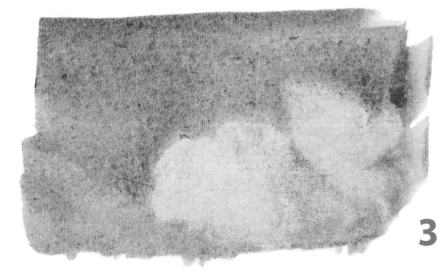

QUICK & CLEVER!

Some colours, such as Phthalo Blue and Permanent Rose, stain, and are difficult to remove. Ultramarine Blue can be removed almost completely to leave a clean white surface so lifting out is an ideal way to get clouds in your blue skies!

3 The result – quick and clever clouds!

SCRAPING BACK

Scraping back is a wonderful technique to use for showing rocks and boulders, or the shapes of tree branches. Time is of the essence here as the paint must not be allowed to dry.

HOW TO SCRAPE BACK...

You need to have the knife or scraping implement handy, before you start painting. Apply the paint, which should be dark; a mix of Ultramarine Blue and Burnt Sienna is good for this effect. Allow a very short time for the paint to settle (a minute at most).

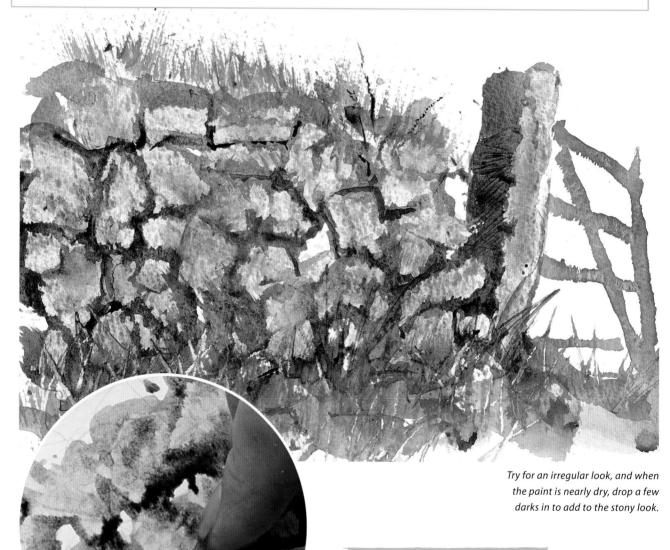

Try for an irregular look, and when the paint is nearly dry, drop a few darks in to add to the stony look.

QUICK & CLEVER!

Some people find it easier to hold the knife by the blade, others prefer not to use a knife, but an implement such as a home-made plastic scraper.

38

MASKING

This technique is ideal for when you want a light colour preserved on a dark background. The only drawback with masking is that masking fluid can ruin brushes; so I have evolved a method that does not need any!

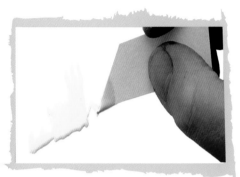

1 Take a piece of thin card, cut as shown. Put a tiny amount of masking fluid into a saucer or similar. Apply some blobs of the fluid to the area to be masked.

2 Use the card to spread the fluid around to cover the shape needed. Make sure there are no gaps or holes in the masking fluid where there should not be. Set aside to dry.

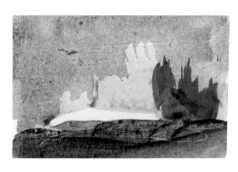

3 Apply the colours as required, making sure they are dark enough, and painting over the masked area. Wait for this to dry.

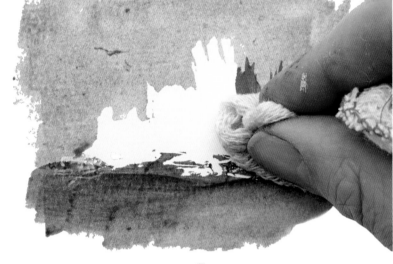

4 Remove the dry masking fluid by gently rubbing across the surface of the paper, a bit at a time. Do not pull with your fingers or you might tear the paper.

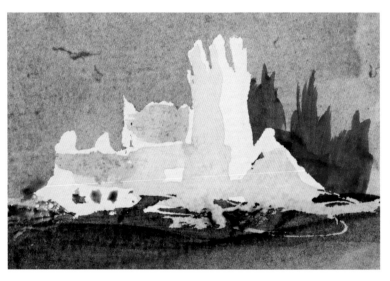

5 Paint the shape you have uncovered, making sure to keep the colours very light to maintain the contrast.

OPAQUE TECHNIQUES

USING ACRYLICS OPAQUELY TAKES US INTO THE OIL PAINTER'S RANGE OF TECHNIQUES, WHERE HEAVY BRUSHSTROKES AND TEXTURAL MARKS ARE USED TO GOOD EFFECT. ONE OF THE MAIN DIFFERENCES BETWEEN OPAQUE AND TRANSPARENT PAINTING IS THAT, IN THE OPAQUE METHOD, WHITE IS USED TO MAKE COLOURS LIGHTER, INSTEAD OF DILUTING THE PAINT WITH WATER.

IMPASTO

This is one of the most impressionistic opaque techniques, where the paint is allowed to retain all the brushstrokes.

It takes a bit of discipline to avoid going back over a brush or knife stroke and it is tempting to smooth out the paint.

If you want to use impasto properly, however, you must learn to make your mark and move on. Probably the best-known exponent of impasto was the Dutch painter Vincent van Gogh. Look at his paintings and observe the brushstrokes. Acrylics are ideal for this technique; if they had been around in his time Vincent would have used them!

QUICK & CLEVER!

You can also apply impasto paint with a painting knife. This allows you to leave loose, sweeping knife marks in the paint.

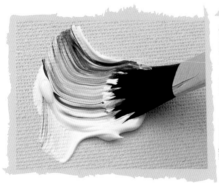

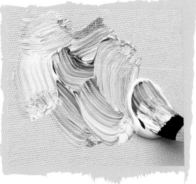

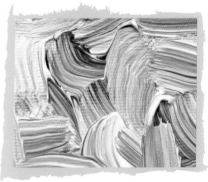

1 Pick up a large blob of paint on a large bristle brush (use the brush like a spoon to pick the paint up), then apply it vigorously to the board. The effect gets really interesting if you apply several colours on the same brush!

2 Pick up more paint and add more strokes adjacent to, but not covering, the previous ones.

3 The effect should look spontaneous, with brushstrokes clearly visible.

SCUMBLING

This is another of the techniques used greatly by the nineteenth-century French impressionists. I can almost smell the absinthe! Scumbling is about gaps in the paint, and letting the underneath colour show through here and there. It's a versatile and useful technique, as shown here.

1 To practise scumbling first apply a ground of colour to the surface.

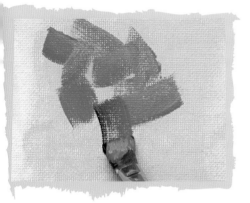

2 Use a bristle brush and apply several brisk brushstrokes, taking care not to merge them together.

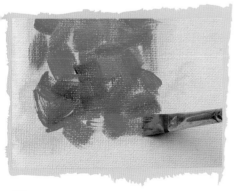

3 Take another colour, or different tone of the same one, and add more brisk brushwork. Apply the colour unevenly, so that the lower layer shows through.

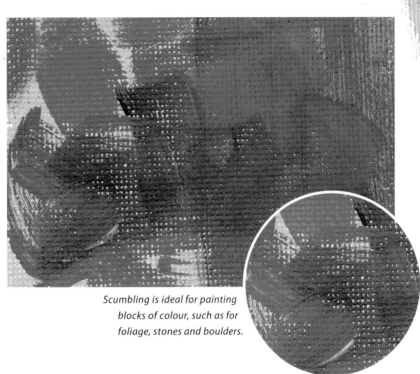

Scumbling is ideal for painting blocks of colour, such as for foliage, stones and boulders.

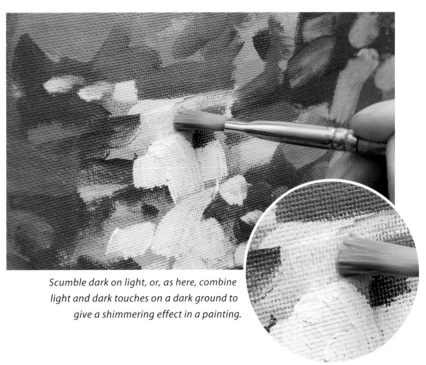

Scumble dark on light, or, as here, combine light and dark touches on a dark ground to give a shimmering effect in a painting.

DRY BRUSH

Applying opaque paint with dry brush is similar to the transparent method, except that the paint is applied with a big bristle brush. Paint is dragged off the brush by the action of the surface. Textured underpainting works well with dry brush, as the texture picks up the paint as it skips over the surface.

HOW TO APPLY DRY BRUSH COLOUR ...

When applying opaque paint using the dry brush method, it helps to hold the brush almost parallel to the paper or board, and touch the flat of the brush with a gentle stroke across the surface.

This painting of an old Spanish church makes use of an opaque dry brush technique, allowing the background colour to show through.

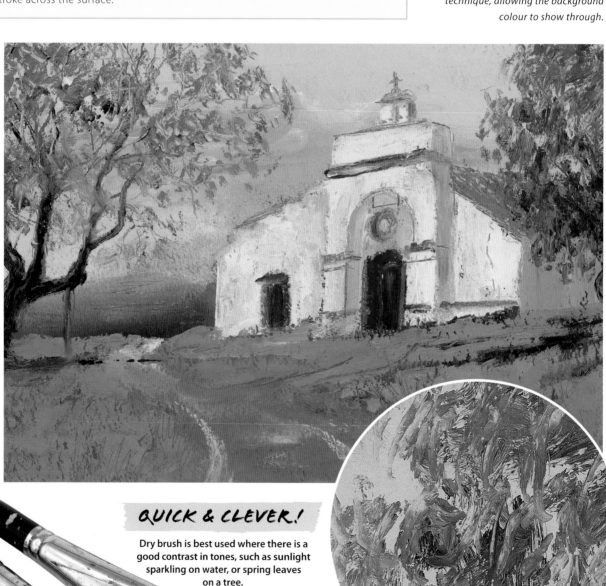

QUICK & CLEVER!

Dry brush is best used where there is a good contrast in tones, such as sunlight sparkling on water, or spring leaves on a tree.

TEXTURING

There are many ways to achieve texture when painting in acrylics, and one of the most effective methods is to use a painting knife. You can create a variety of effects by using the blade of the knife in different ways, and by combining colours.

KNIFE EDGE

Using the knife on its edge, pick up ridges of paint and apply them vigorously. Slice across the board to raise more ridges. Be careful not to apply too much force, otherwise you could actually slice the support!

FLAT BLADE

Use the blade flat against the board. Rapidly lifting off the blade raises an interesting texture.

MULTI-COLOUR

Put different coloured blobs of paint close together on a flat surface and scrape them up with the knife; when applied, this gives a fascinating irregular ripple effect.

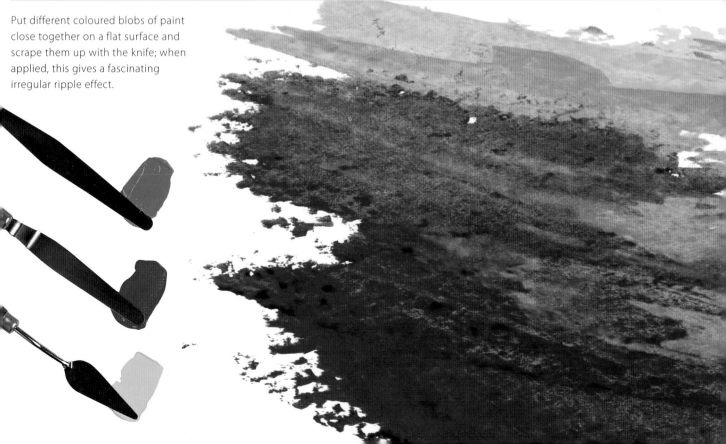

SPONGING

A sponge can be used in both opaque and transparent methods. A natural sponge is best for creating a stippling effect, but make sure that you wash it thoroughly after use, otherwise it will go hard and lose its absorbency. A synthetic sponge will give more regular-looking marks.

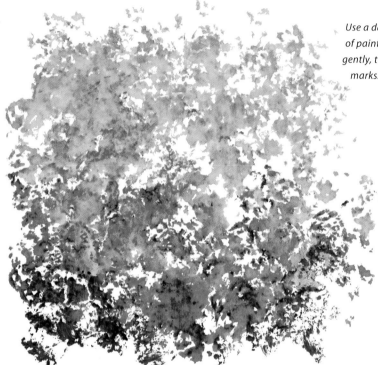

Use a damp sponge, and dip it into a layer of paint on a flat acrylic palette. Apply gently, turning the sponge to avoid repetitive marks.

QUICK & CLEVER!

Squeeze the sponge for runny effects, and stroke the surface gently for a drier look.

Use a damp sponge to apply thin paint. This gives wonderful streaky effects that are ideal for slow-running water and reflections.

SPATTERING

This is one of my favourites. If you are going to practise this technique in a group, be careful who sits next to you; it could cause an argument!

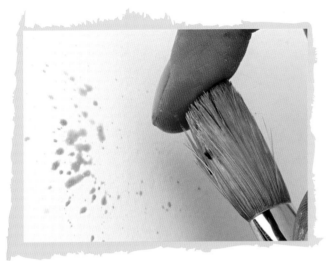

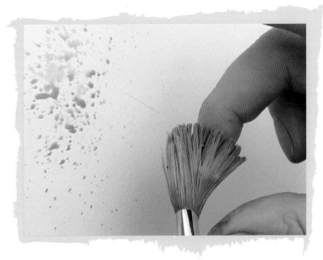

1 Use a large bristle brush that is well loaded with paint. The paint should be slightly diluted, but not too watery. Hold the brush a couple of centimetres or so above the surface, as shown, and pull the bristles back.

2 Release the bristles so they snap back into place. The amount and size of the spatter depends upon how thick the paint is, and how far away you hold the brush.

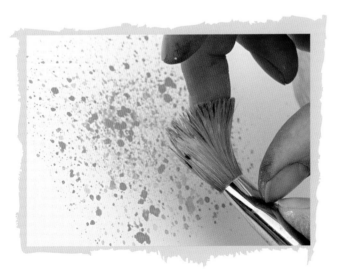

3 Continue spattering until the desired effect is achieved, or until the person next to you complains!

This is an ideal method for achieving the look of sand or gravel, texture on stones, and distant flowers or leaves.

QUICK & CLEVER!

You can control where the spatter goes by using a mask. Tear a hole in a piece of newspaper, lay the paper on the painting, and spatter through the hole.

UNDERPAINTING, OVERPAINTING & GLAZING

These processes make up the most important and traditional technique of all the opaque methods. You need to be able to think like a house painter to understand how it works. If you have done some DIY, that helps!

Imagine painting a wall. You prepare the surface. Then you apply one coat of undercoat, then two top coats, and finally a decorative finish. That's how underpainting, overpainting and glazing works.

UNDERCOAT
You apply no detail whatsoever to start, with basic colour painted very simply, in 'blocks', on a prepared board or canvas. Known as 'blocking in', this first coat of paint covers the complete board. Think of it as undercoat.

TOPCOAT
Next is the first topcoat; this allows you to tidy up and adjust the colour, starting with the background. Then the second topcoat is applied: adding touches of detail, adjusting tones, adding spots of colour here and there.

THE FINISH
Finally, if needed, is the glazing: putting a coloured varnish, called a glaze, over areas that need subtle colour adjustment, but are otherwise OK.

To see this method in action, we are going to paint a simple mountain stream to show you how to proceed. Paint along with me, if you want, so you get the idea.

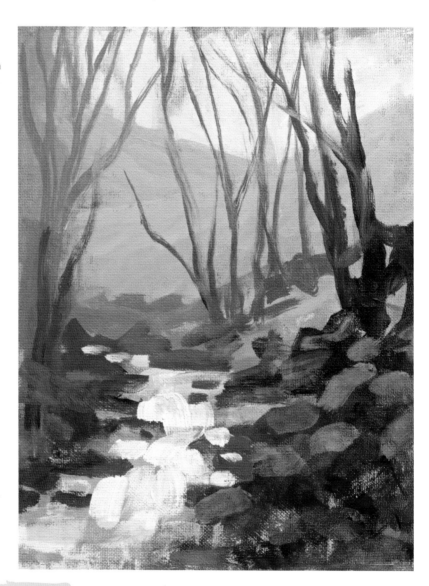

Following the demonstration will reveal how this opaque technique works, layer by layer, resulting in a tranquil mountain stream.

YOU WILL NEED:
- board, about 25 x 30cm (10 x 12in)
- white acrylic gesso, Ultramarine Blue, Phthalo Blue, Burnt Sienna, Lemon Yellow, Permanent Rose, Naples Yellow and Titanium White
- matt medium
- brushes: no.10 bristle brush
- acrylic stay-wet palette, jar of water

UNDERPAINTING

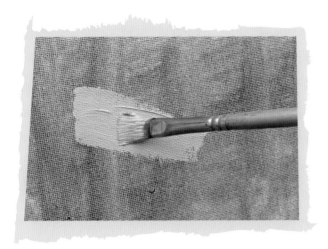

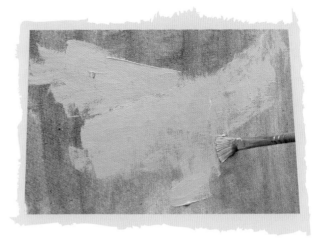

1 Prime a piece of cardboard, or canvas board, with some white acrylic gesso, and leave to dry. Brush on a dilute grey mix of a little Ultramarine Blue and Burnt Sienna, and set aside to dry completely. Then, paint a distant hill with a mix of Titanium White and a touch of Ultramarine Blue, using a no.10 bristle brush. Do not try to make this neat and tidy; undercoat, remember!

2 Continue with the background, blocking in the nearer hill by adding a touch of Lemon Yellow to the distant blue colour, to make a strong green; and save a little of this for later. Paint with a vigorous brushstroke; let the strokes stay visible, and do not get fiddly! Undercoat, undercoat.

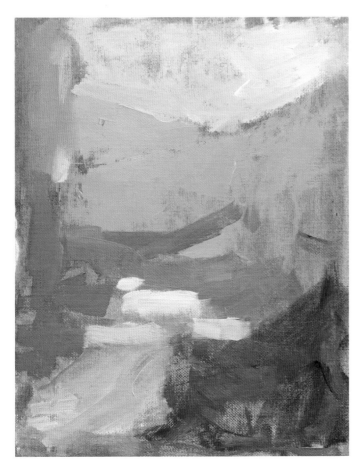

3 Block in the sky, using Titanium White with tiny touches of Ultramarine Blue and Burnt Sienna added, and the stream in the same colour. Allow the background grey to show through here and there. Mix some Permanent Rose, Ultramarine Blue and a little Burnt Sienna together to make a dark violet–grey, and block in the bottom right. Use a paler version of this (by adding white), for some touches on the left edge of the stream. Almost everything has been blocked in; now for the next stage.

QUICK & CLEVER!

Making brushstrokes run down a hill will accentuate the look of a slope.

OVERPAINTING

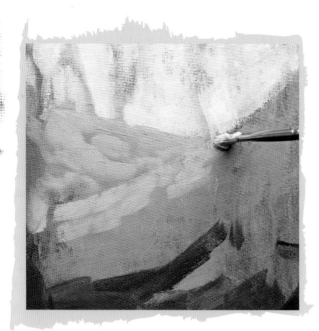

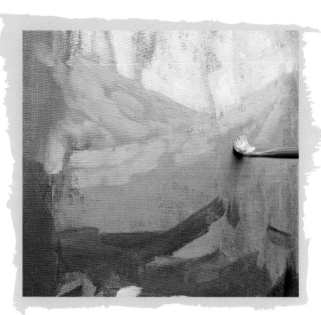

4 Add a tiny pinprick of Phthalo Blue to some Titanium White, and overpaint the sky area, leaving some background colour showing through to denote trees. Scumble a loosely brushed pale mix of white, Ultramarine Blue and Permanent Rose, with a touch of Naples Yellow, over the distant blue hill, letting some original colour show through. Do not make it too neat and tidy!

5 Overpaint the green hill with a scumble of a paler blue-green, allowing the background colour to show through in places. If you have some original paint from the green hill (see step 2), add white and a touch of blue to it for this. Make your brushstrokes diagonal, running down from right to left to give the impression of a slope.

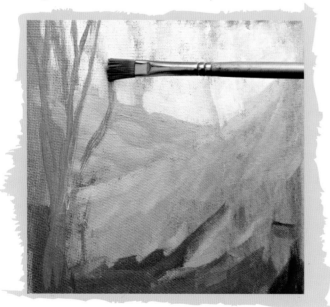

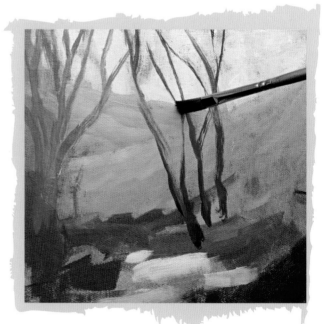

6 Make a mid grey from Titanium White, Ultramarine Blue and Burnt Sienna. Add a tiny touch of Permanent Rose to give it a slightly violet tinge, and using the brush on its edge, overpaint in some winter trees on the left. Start from the ground and work up, holding the brush way back and applying less pressure near the top so the trees get thinner.

7 Use the same technique for the right-hand trees, adding a touch of Phthalo Blue to the mix to give a slightly darker colour. Link them at the base with the same colour. Add a little Burnt Sienna to the mix and paint some nearer trees in the same way; they will look nearer because they are darker. Link their bases with this darker colour and add some boulders, overpainting on to the dark violet-grey area on the bottom right, and in the stream.

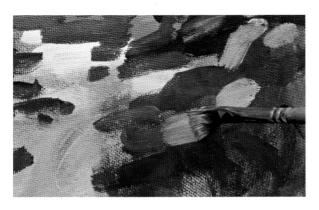

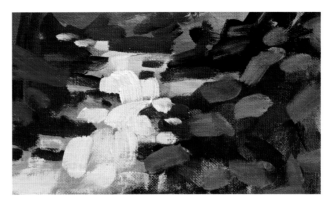

8 With a mix of Titanium White, Ultramarine Blue and a touch of Burnt Sienna to make a pale blue–grey, paint the lighter tops of some boulders near the bottom on both sides of the stream.

9 Take some Titanium White and, starting with some small touches further back, add brightness to the stream. Nearer, the brushstrokes can be almost vertical, to imply waterfalls. Now, are you starting to get too neat and fiddly? If you are, overpaint the 'fiddle' with some heavyweight brushstrokes. It should look like a painting, not a photo. Set the painting aside to dry. Have a break; you are doing well, I can tell!

GLAZING

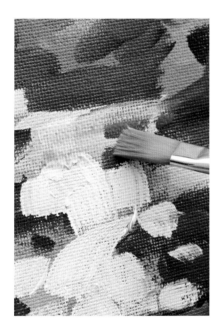

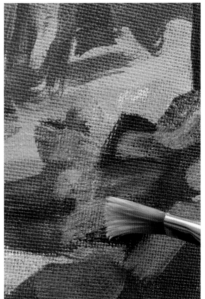

QUICK & CLEVER!

Looking at the demonstration I painted, I realized that I did not like the inch or so either side of the painting. What to do? If this happens to you, get a mount cut. A mount is a decorative card that surrounds a painting before it is put behind glass. I chose a red one, and it has hidden the bits I did not like.

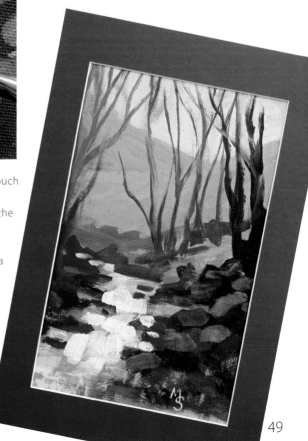

10 Now for some glazing. Mix a touch of Phthalo Blue with a little Lemon Yellow into some acrylic matt medium. You need much more medium than paint for this. Try the mix first on a piece of scrap paper; it should be a pale, transparent blue-green. If it is too dark, add a bit more medium. Brush this on to the stream here and there to look like shadows on the water. Make sure the painting is perfectly dry first.

11 Make another glaze. Add a touch of Lemon Yellow to the matt medium. Brush this on to the area at the base of the trees on the right; it will look like sun catching the grass. Mix some Permanent Rose into this, with a touch of Burnt Sienna, and glaze over the boulders on the right, adding a touch to the left also. That looks pretty good.

START PAINTING!

Now let us get started on some real paintings!

The projects that follow will guide you through the processes of producing exciting images in acrylics. At the start of each project I have demonstrated a few techniques used during the painting; give yourself plenty of time to practise these before starting on the real thing. If you wish, you can use cheap paper to practise these techniques on.

Then, when you have developed your confidence, try doing the complete painting as I have, step by step. I have described each stage for you, including the colour mixes. The close-up shots of paint being applied will enable you to see how the brush is used.

The first three paintings use the transparent method: making paint paler by adding water, using watercolour-type brushes, on watercolour paper. Have a thin strip of the same paper that you are painting on, beside your work, to test colours before you apply them so you know if the dilution is correct. You will need two water jars: one for dipping into, one for washing your brushes. Acrylic flow improver will make the washes look more even, but is not essential.

Two projects then follow that use the opaque method: making paint paler by adding white, using oils-type brushes or knives, on card or board. The final project combines methods and techniques.

QUICK & CLEVER
LANDSCAPES

This simple landscape is a warm painting, and it evokes the quiet of evening. The sky is pale yellow, instead of blue, and the image has a unity provided by the first overall wash, which pulls the colours together and creates harmony. Painting this, you will learn tones, colour temperature and brushwork. Now, take a little time to practise the techniques.

YOU WILL NEED:
- 4B pencil
- 425gsm (200lb) watercolour paper and a board
- Paints: see swatches, right
- Brushes: 25mm (1in) flat, 12mm (½in) flat, no. 6 round, no. 2 round synthetic sables
- Painting knife
- Watercolour palette, jars
- Acrylic flow improver (optional)

Lemon Yellow

Cadmium Yellow Deep

Raw Sienna

Burnt Sienna

Ultramarine Blue

Phthalo Blue

Sap Green

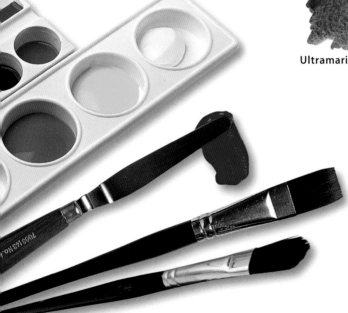

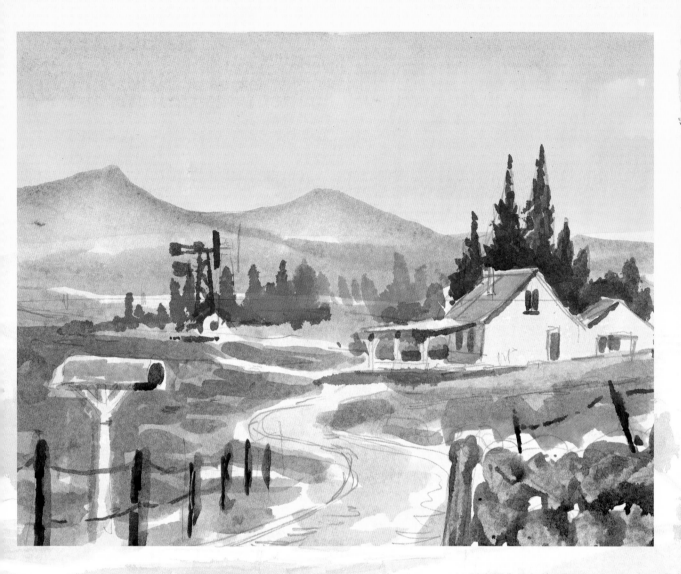

SIMPLE LANDSCAPE (SEE PAGE 58)

This painting uses wet washes, where the white of the watercolour paper is allowed to show through here and there, giving a lively look. Before starting on this image you should have a go at the techniques on pages 54–57, to practise enlarging an image, using tones, scraping back, and painting trees.

USING A GRID TO ENLARGE A DRAWING

Before starting you need to scale up from a smaller image, such as a photograph or sketch, to a larger one. One of the easiest ways to do this is by using a grid. Do not worry; this does not involve advanced mathematics!

The way to make enlarging easier is to divide the small image into sections, which means you only need to concentrate on one section at a time.

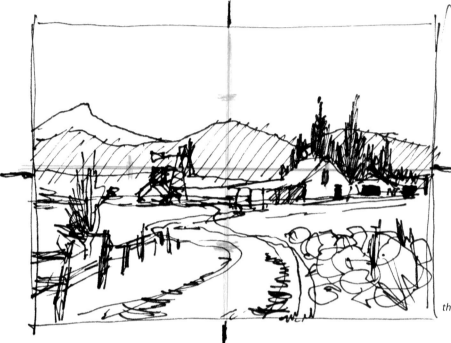

QUICK & CLEVER!

The simplest division is into quarters (see, I told you it was easy); this enables you to see where the middle of the image is, and how various parts relate to one another. I have done this in red on the small sketch.

Use a simple quartered grid like this to make enlarging easy.

Use a soft (4B) pencil, and mark the same quarter divisions on the larger watercolour paper. Even Leonardo da Vinci used this method, so you are in good company! Now just concentrate on one rectangle at a time, looking at where the various elements are within that area, and draw them on to the larger paper. Try practising this technique later with an image of your own, but for now, concentrate on enlarging my sketch onto your paper. Then we shall work through some exercises, practising using tones, and painting tree shapes, before returning to finish this painting. Do not skip these practice sessions; you will feel more confident if you practise!

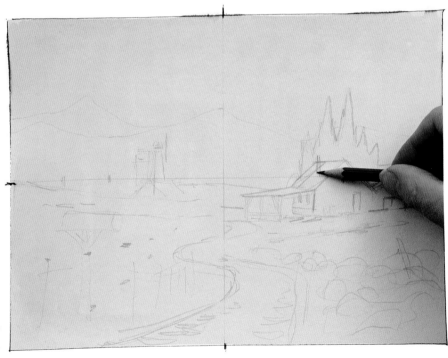

Concentrate on one area at a time.

TONAL VALUES

Which one of these buildings stands out? Yes, the one on the right. It has more contrast because it has dark trees behind it. This contrast of tone between light and dark is called 'tonal value'.

It is worth practising these two little images to see if you can get the same result. First, draw two simple house shapes. Then paint a pale blue hill behind both of them. Use Ultramarine Blue, diluted with plenty of water, and simply paint around the house shapes. Make sure the blue is really pale.

When both are dry, carefully paint the roofs of both buildings using the pale blue colour with a tiny amount of Burnt Sienna added to it. Leave to dry, then use some Sap Green with a bit of Burnt Sienna added to it and paint some simple tree shapes behind one of the houses. See how doing this makes the house stand out? You are using tone to achieve definition. If you have not got enough contrast, give the trees a second coat and make them darker.

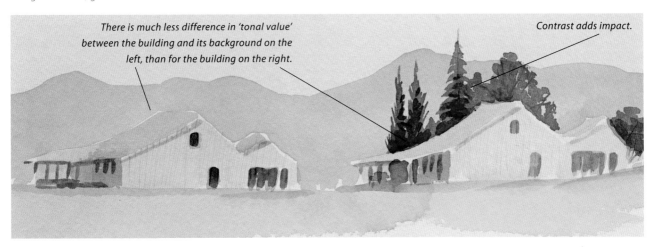

There is much less difference in 'tonal value' between the building and its background on the left, than for the building on the right.

Contrast adds impact.

AERIAL PERSPECTIVE...

If you look at any landscape that has distance you will notice two things: the far horizon is not very sharp, and it often looks slightly blue. You can use this 'aerial perspective' to good effect in your paintings.

Try the exercise on page 62.

By making the distance cool or bluish, blurry, and without contrast, and the near part or foreground warm with a touch of brown or red mixed with your colours you create the illusion of depth, and distance. This works even better if the nearest area has most contrast. In this image of Spain, you can see that even the darker touches in the distance have a blue look to them, and the foreground has the most contrast.

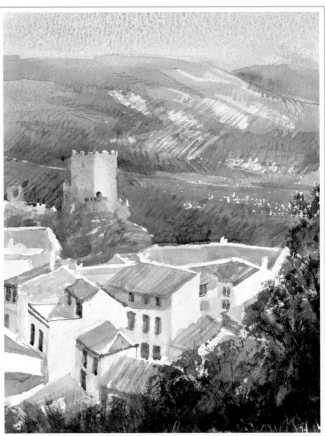

This image uses both colour temperature and tone to achieve the desired effect.

SCRAPING BACK

This is a useful technique for painting textured subjects such as boulders or stone walls. To practise it, take some Ultramarine Blue and Burnt Sienna (not too diluted), watercolour paper and a painting knife.

SCRAPING BACK BARE ROCKS...

Apply the paint, which must be fairly dark, with a large brush. Then, within a couple of minutes, before the paint has a chance to dry, use a scraping action, like buttering bread, to scrape the wet paint around and expose the paper. This technique takes a bit of practice, but do not give up; the effects are worth it!

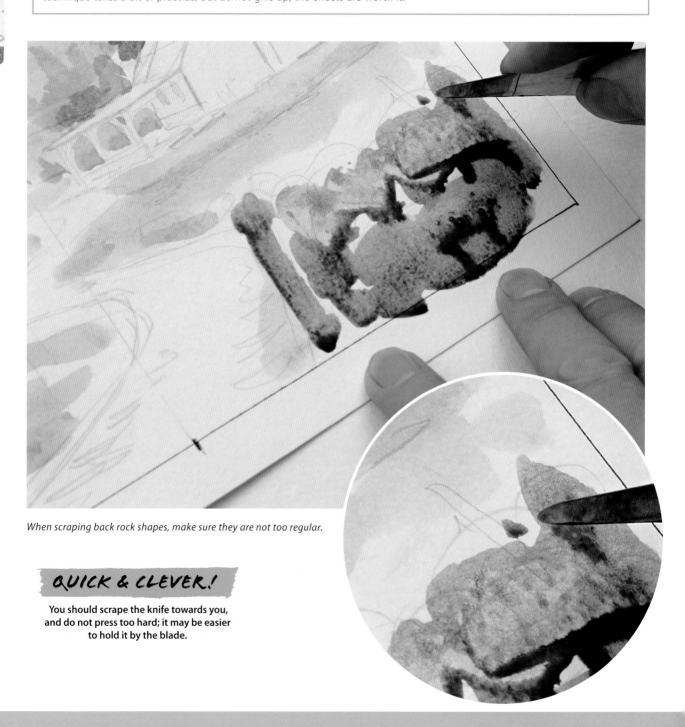

When scraping back rock shapes, make sure they are not too regular.

QUICK & CLEVER!

You should scrape the knife towards you, and do not press too hard; it may be easier to hold it by the blade.

PAINTING TREES

When painting trees it helps to simplify the shapes; you can then apply the masses of foliage fairly easily. Bear in mind that trees are usually lighter on top than underneath, and are often lighter on one side than the other. Simply putting a shadow on one side makes the tree look more solid.

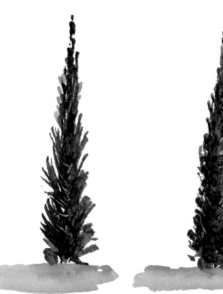

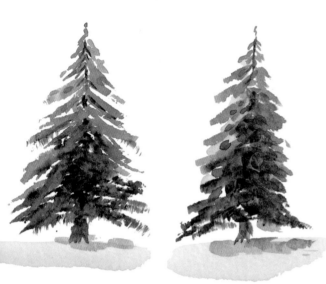

Adding a touch of shadow on one side, and underneath, makes these trees look solid.

Strong linear shapes like cypress or poplars can be implied with very few strokes.

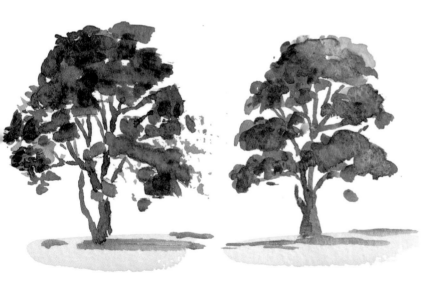

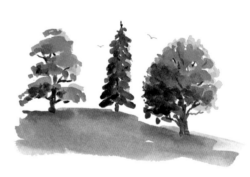

Distant trees, like this little group, need to be simplified even more, and kept quite pale.

Simplify trees when painting them; do not try to paint every branch, or indicate every leaf shape.

QUICK & CLEVER!

A common mistake is to make trees too green! Quite often they are brownish, so an addition of Burnt Sienna to the green gives a more realistic colour. Spring greens on a tree, when the leaves have just come out, can be achieved by spattering. Winter tree shapes are best painted in neutral colours, with brighter colours dropped in before the paint dries.

QUICK & CLEVER PAINTING
SIMPLE LANDSCAPE

You have had a bit of practice, so now is the time to put your new skills to work on this landscape. Do not worry too much about being neat and tidy; just enjoy the flow of the paint and have fun!

SUBJECT 1

1 Cover the paper with a watery wash of Raw Sienna using a 25mm (1in) flat brush (it is helpful to add a few drops of flow improver to the water). Let it dry completely. Using the grid method, and a 4B pencil, draw the shape of the landscape. Then apply the sky with a further dilute wash of Raw Sienna and a hint of Cadmium Yellow Deep, coming down over the mountains. Save some of this colour for the next step.

QUICK & CLEVER!

When drawing the grid, keep it simple, and do not press too hard on the pencil.

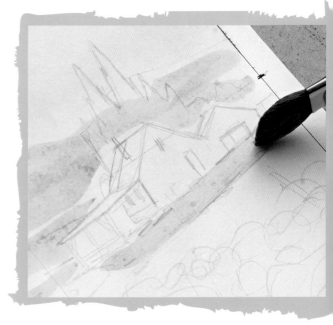

2 Take some of the colour used for the sky. Add a little Ultramarine Blue, a tiny touch of Phthalo Blue, and apply the mountains with the 25mm (1in) brush. The colour should be blue-grey and not too dark. It is OK if this appears a little streaky. Run a touch of clean water along the bottom edge of this colour, with another brush, to avoid a hard edge.

3 Add some Lemon Yellow to the mountain colour, and paint a few horizontal blue-green stripes below the mountains. Avoid painting the area where the house is; paint carefully around and underneath it. Do not worry if there are some streaks or some bits are left unpainted; these can be painted later if needed, without disturbing the colour already applied. This is one of the many advantages of acrylics over watercolour.

4 Now add some Raw Sienna to this blue-green mix, and apply the lower areas of green, painting carefully around the mailbox, post and track, with a no. 6 round brush. This green should be slightly darker, and warmer, than the last step, but remember, it is OK to leave some white bits. Save some of the green for later. Leave the bottom right unpainted; that is where the stone wall will be.

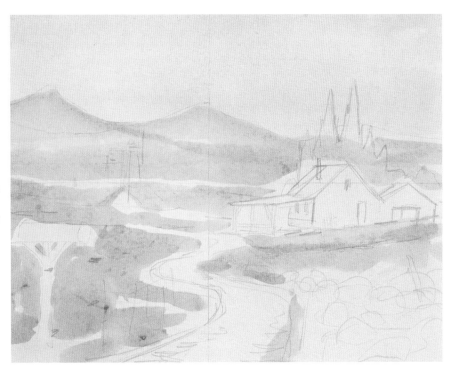

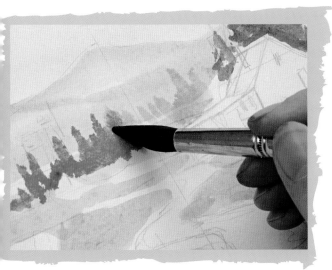

5 Mix a darker green for the trees, using Sap Green, Phthalo Blue and a little Raw Sienna. Using the no. 6 brush, carefully paint around the outside edge of the building's roof, then develop the trees upwards; these need to be quite dark. If your trees are not dark enough, do not worry; you can give them another coat later. Dilute this colour, then continue with the trees on the left – paler, and smaller, as they are farther away. Leave a small triangle shape unpainted, for the building near the pump.

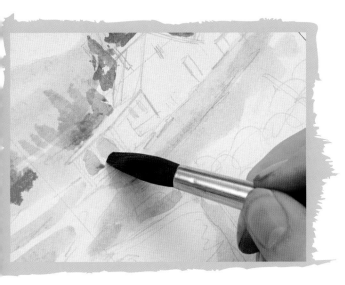

6 Using some of the green from step 4, plus a tiny touch of dilute Phthlo Blue, carefully paint around the posts on the veranda, left of the building. You are now halfway through, so it is a good time to sit back and look at your work. Are you creating enough contrast with light and dark tones? Does the building stand out? Avoid flat areas of uninteresting colour; runs or streaks all add to the look of a real painting!

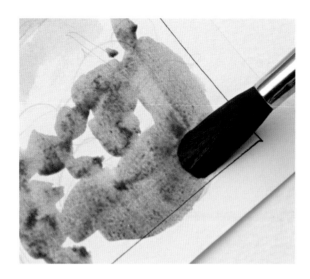

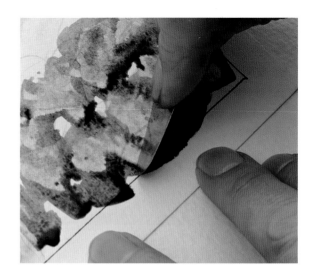

7 Mix a dark grey from Ultramarine Blue and Burnt Sienna. Make sure you have a painting knife ready; you will need it as soon as you finish putting the paint on. Now, paint an irregular rectangle at the bottom right, leaving some unpainted gaps and an irregular-shaped top.

8 Take a painting knife and scrape out some stones before the paint dries, within a minute or two. You may like to practise the technique on a separate piece of paper first. Try to get an irregular look with this. Before the area is dry, drop in a few touches of Burnt Sienna.

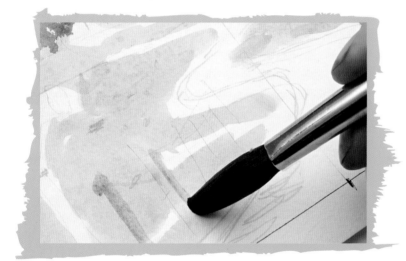

9 The grey colour from the step 7 is used to paint the fence posts on the left. Start with the left-hand one, then make them smaller and closer together as they get farther away. Add a touch of water for the distant ones. This will give the look of a receding landscape. If the posts are too pale you can come back to them later.

10 Now we are ready to add detail, using the no. 2 round brush. First paint the wire joining the posts, with the same grey. Do not worry if you have a shaky hand; the posts look better if they are wobbly! Use the same brush for the end of the mailbox, and windows and details on the buildings.

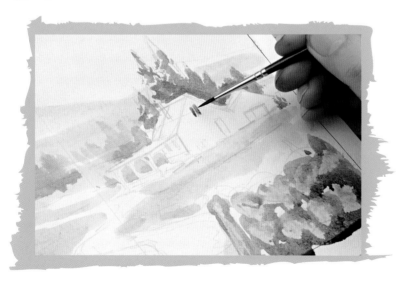

QUICK & CLEVER!

If some of your colours are too pale, do not worry. Another layer of a similar colour will darken them; you can add this later.

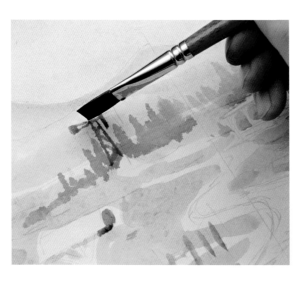

11 Apply the thin lines of the wind pump on the left with a mid blue-grey mixed from dilute Ultramarine Blue with a touch of Burnt Sienna. You can use the edge of the 12mm (½in) flat brush for this, or the no. 2 round. If you use the flat brush, practise first on some scrap paper. Leave the little triangle at the base unpainted; it will look like a building if you add a window. Using the same brush, add some fence posts to the wall in the foreground.

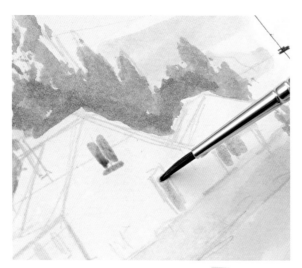

12 To complete the painting dilute the wind pump colour. Using the 12mm (½in) brush, use this colour to apply shadow on the building, and pale grey on the roof, and also the mailbox. Make sure it is not too dark, or you will lose the contrast. Add grey to the guttering under the roof. Paint a warm wash of dilute Burnt Sienna on the track near the fence, but do not take this all the way up or you will lose the look of distance. Finally, put in a shadow on the left of the veranda, to make the buildings look more solid. Well done!

QUICK & CLEVER!

If you need to make any adjustments, such as darkening the trees behind the house, take care. Do not spoil your work by overdoing it. With art, it is always a good thing to quit while you are ahead!

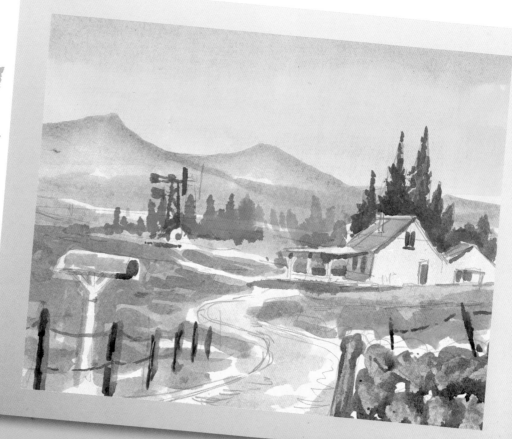

QUICK & CLEVER VARIATION
AERIAL PERSPECTIVE LANDSCAPE

This simple exercise shows you another simple landscape, but puts more emphasis on aerial perspective. It will teach you about colour temperature, and enable you to choose colours that will make your paintings have distance or 'recession'.

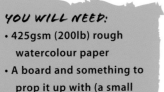

Before painting, tape the paper to the board, draw a horizon line across it about a third of the way down, and prop it up slightly. Have dilute mixes of Ultramarine Blue, Phthalo Blue, Lemon Yellow, and Cadmium Yellow Deep, with plenty of water and a touch of flow improver, in separate wells of your watercolour palette ready to paint.

Wet the whole paper, using clean water with a few drops of flow improver. When the shine has just gone off the paper surface, it is ready.

YOU WILL NEED:

- 425gsm (200lb) rough watercolour paper
- A board and something to prop it up with (a small book would do)
- Paints: Ultramarine Blue, Phthalo Blue, Lemon Yellow, Cadmium Yellow Deep, Burnt Sienna
- Brushes: 50mm (2in) hake or 25mm (1in) flat brush, no. 10 round and no. 6 round synthetic sables
- Watercolour palette, jars
- Acrylic flow improver (if you have some)

QUICK & CLEVER!

If you get dribbles of paint when the paper is turned down sideways, these will run off the side of your image, not down on to the landscape area, and can be wiped away. When you turn the painting back the right way, any streaks that remain will be horizontal, and will look like clouds!

1 A sky and distance are best painted with the paper turned so that the horizon is vertical. Using the 50mm (2in) hake, or a 25mm (1in) flat brush, wash on a strip of diluted Ultramarine Blue. Next add more water and a touch of Phthalo Blue to this and make another strip overlapping the previous one by half a brush width. Overlap the next stroke in the same way, adding a touch more water. Do this for three or four strips. The sky should get paler, and cooler, as you go.

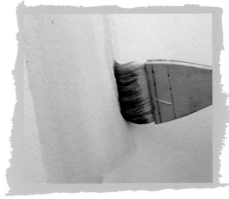

2 Now take some of the Ultramarine Blue sky colour and apply a thin band of blue at the bottom of the sky, for a distant hill. If you have painted it correctly, this will be slightly darker than the sky at this point. If the paper is still damp, the edge will be soft and fuzzy. Continue by adding a touch of Lemon Yellow and a tiny touch of Phthalo Blue with a few drops of water to make a pale blue-green for distant fields. Apply a couple of strips of this colour.

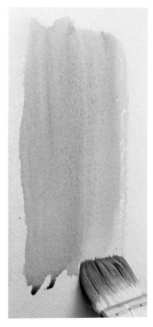

3 Working quickly so as to keep a wet edge, add a tiny touch of Cadmium Yellow Deep to the blue-green to make a slightly warmer green. You should now be in about the middle of the image. Apply a couple of strips of this colour, overlapping each one slightly as you go, like you did with the sky. Leave a white, unpainted bit here and there; these areas can become buildings later.

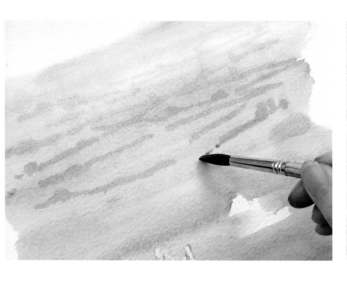

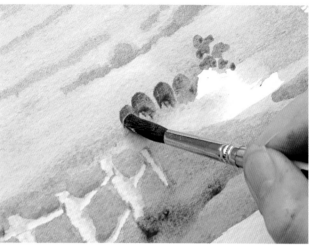

4 Adding a little more Cadmium Yellow, and some Ultramarine Blue, will give you a slightly darker and warmer green, which can be applied in the same way, taking care to overlap. A little touch of Burnt Sienna mixed with this green warms it still further for the foreground; when painting this, leave an unpainted bit for the road. While this area is still wet, it is also possible to scrape back to show some detail such as the fence posts.

5 Now for detail! To keep the distant look, paint features such as hedges or trees onto the blue-green area with a very pale Phthalo Blue, using a no. 6 round brush. Remember, distance makes things appear smaller as well as more faint! Working on nearer features, it is possible to use a slightly darker and warmer Ultramarine Blue colour for trees and bushes. The green background colour will modify it and give it a green look.

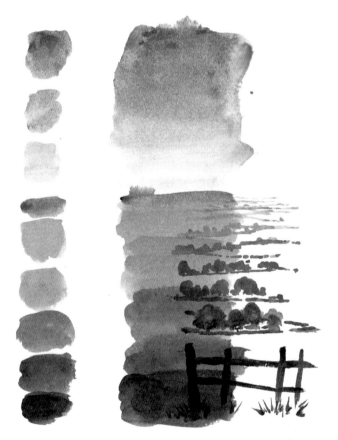

Distance is implied by using dilute blue-greens, with subtle changes of tone. Greens get warmer and darker as they get nearer. Note the only brown colour is right at the bottom, where it looks quite close.

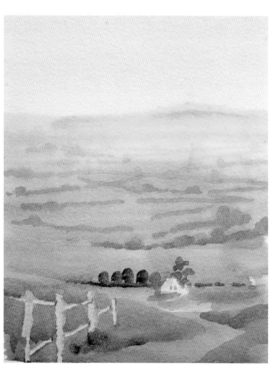

6 Painting a warmer green over the foreground area establishes its strength and allows elements like pathways and tracks to be developed. Enhance the hint of a building by putting some darks behind it. The overall effect you are aiming for is a look of distance, with cool hazy blue tints and hardly any detail in the background, and warm brownish green colours and more contrast up close. Congratulations. You have created the illusion of space. Excellent!

QUICK & CLEVER

BOATS

Painted in the watercolour technique, this restful image will show you how to paint believable reflections using flat brushes, a quick way of drawing boats, and a clever way to paint fine lines like ropes and masts without needing a brush. As before, take some time to practise the techniques, and when you are happy using them, start painting.

YOU WILL NEED:
- 4B pencil and sketchpad
- 425gsm (200lb) watercolour paper and a board
- Paints: see swatches, right
- Brushes: 25mm (1in) flat, 12mm (½in) flat, no. 2 synthetic sable
- Watercolour palette, jars
- Scraps of watercolour paper or thin card

Lemon Yellow Cadmium Yellow Deep

Raw Sienna Burnt Sienna

Ultramarine Blue Phthalo Blue

Cadmium Red Light

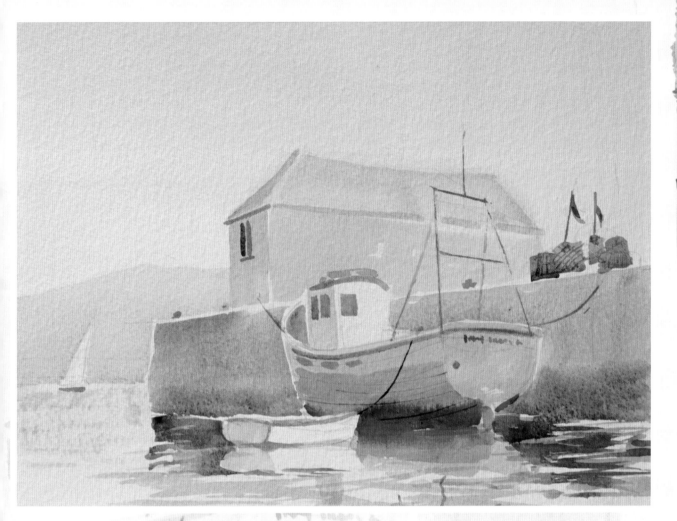

BOATS ON THE WATER *(SEE PAGE 68)*

The painting here uses the watercolour technique of building up layers, using flat brushes to good effect. Pages 66–67 show you how to draw boats and paint simple reflections that look good, so practise these before starting on your painting.

DRAWING BOATS

I used to live on a residential boat on the river Thames, near London, and so I spent plenty of time looking at boats. This method of drawing works well for the 'three-quarter' view, when you can see a little bit of one side, and a lot of the other side. Do not tell me you cannot draw boats, I do not believe you; try this!

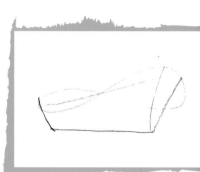

1 Draw a straight line, sloping up to the right. Then draw a stretched figure of eight on its side, around the line, making one 'bowl' of the shape bigger than the other. It works best if the largest bowl is on the higher side. Make sure that the shape is stretched and not too short or dumpy.

2 Add a horizontal line under the figure of eight, a little below it. From the middle top of the larger bowl, draw a slightly curved line down to meet the horizontal line.

3 Add a line down and curving in slightly from the left-hand side to meet the horizontal, and one on the far right. Make the curves fairly gentle, and avoid sharp angles.

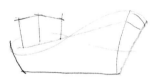

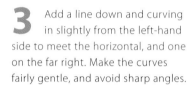

4 Rub out the unwanted part of the figure of eight on the right. Add a simple box shape. This can be at the front or back, depending on the kind of boat, so you cannot go wrong!

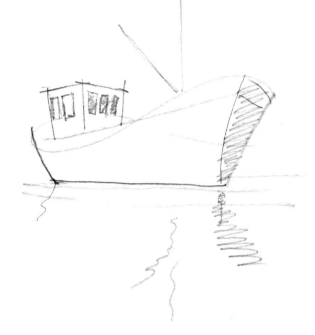

5 Draw some elongated rectangles on the box, making sure that they are taller than they are wide, and that there is not too big a gap between them.

6 To make the boat look solid, all it takes is a bit of shading on one side. Decide where you want the shadow side to be, and shade it in with your pencil. Add a few lines for some rigging. If you want a boat pointing the other way, start with the straight line sloping up to the left, and put the largest bowl of the figure of eight on that side. Before you finish, scribble in some wiggly lines under the front and back (fore and aft, if you are a nautical person) – and you have an impression of water.

PAINTING WATER REFLECTIONS AND RIPPLES

Students often ask how to paint water. Actually, that is not the question they mean to ask. What they really mean is 'how can I paint effects that look like the surface of water'. Reflections and ripples are what give water its character, and one of the easiest ways of painting these is with a flat 12mm (½in) brush.

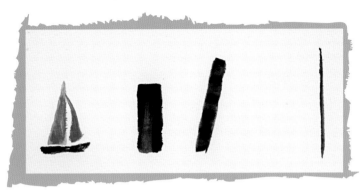

1 First, let us paint some objects that might be reflected: a boat, posts and a thin shape like grass or reeds. Paint these, fairly dark, on watercolour paper, allowing space under each shape for the reflection.

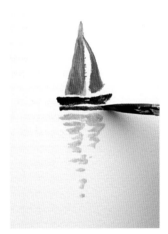

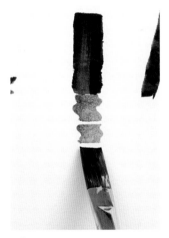

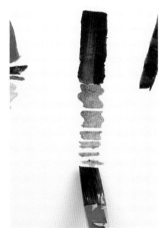

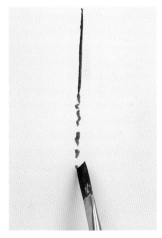

2 Reflections are always underneath the object that is being reflected; and the shape of the reflection echoes the object's shape. Usually, the colour is less intense than the colour of the real thing, and the shape is often broken. Paint this sail in a series of strokes; the more horizontal the brushstroke, the better the effect.

3 Use a 12mm (½in) brush for these rippled reflections of the posts. Making sure the brushstrokes stay almost under the post, draw the brush down and wiggle it slightly as you do so.

4 As the reflection moves further away from the object, the shape breaks and becomes less distinct. Capture this effect by making smaller brushstrokes, and leaving bigger gaps between them.

5 Thin objects make thin, wobbly reflections on the water. Make sure that the reflection is always underneath the object. If the object leans, the reflection must lean the same way.

6 If you have painted these items as a group, you can paint some additional lines between them, in a pale colour, to act as a link and look like ripples. Use the flat brush on its edge for this. Colours of reflections vary, but pale green-greys and blue-greys work well for these effects.

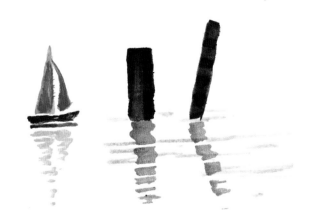

QUICK & CLEVER PAINTING
BOATS ON THE WATER

It is always a good idea to start with a little drawing, to see how all the elements of the picture fit together. It does not matter if you are not good at drawing; you will get better with practice. The drawing is only to enable you to plan your painting.

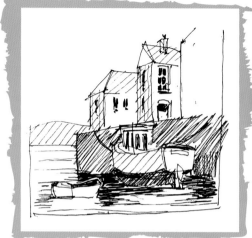

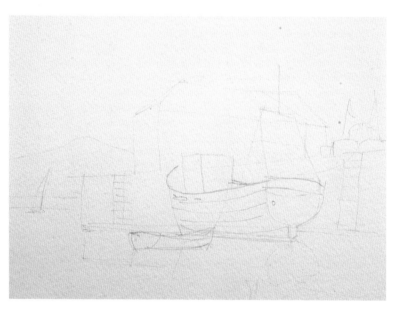

1 Use the simple grid method to transfer the image to the paper, using a soft, 4B pencil. Do not worry about getting it exact; the scene does not actually exist, so no one can say you have made a mistake! When you have finished the drawing, wash over the complete paper with a mix of Raw Sienna, and a touch of Cadmium Yellow Deep, using a hake, or a 25mm (1in) flat brush. Then leave to dry.

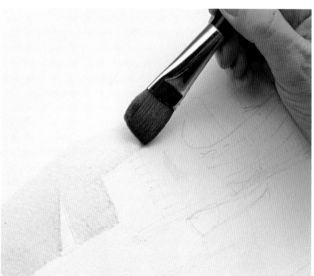

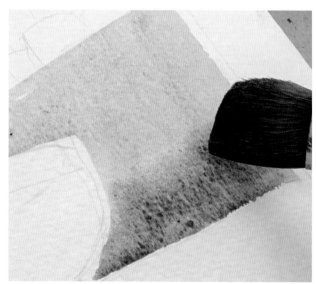

2 Add some Ultramarine Blue into the mix to make a pale grey for the distant hill. Apply this with a 25mm (1in) flat brush, leaving a little unpainted triangle for the sail of a small yacht. Use the same colour for the roof of the building. Allow this to dry.

3 Mix Ultramarine Blue and Burnt Sienna for the harbour wall; this is darker and warmer than the distant hill, so it looks nearer. With this colour, paint round the boat shape carefully, and the rest of the wall. Add a touch of darker paint to the base of the wall while still wet to add contrast.

SUBJECT 2

4 While this is drying, add a little Lemon Yellow to the wall colour, and a touch more Ultramarine Blue, and paint the water under the wall using the 25mm (1in) flat brush. Leave plenty of horizontal white areas to look like ripples. Leave the reflections of the boats unpainted for now.

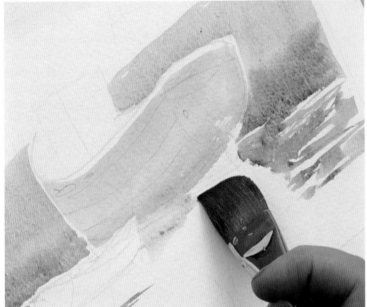

5 When the wall is dry, paint the trawler a dilute mix of Lemon Yellow with a touch of Phthalo Blue. Keep it pale for contrast, and leave some white around it. Dilute this colour for the reflection. Be careful; do not paint over the white rowing boat by mistake!

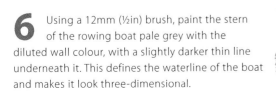

6 Using a 12mm (½in) brush, paint the stern of the rowing boat pale grey with the diluted wall colour, with a slightly darker thin line underneath it. This defines the waterline of the boat and makes it look three-dimensional.

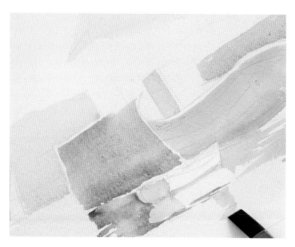

7 Use a similar colour to the stern of the rowing boat for the shadow side of the cabin, applied with one stroke of the 12mm (½in) brush. The windows will come later. Paint a reflection of this, below the reflection of the little white boat.

8 Paint the end of the building a pale brownish grey, using the 12mm (½in) brush, and define the guttering to give more solidity to it.

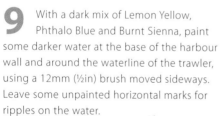

9 With a dark mix of Lemon Yellow, Phthalo Blue and Burnt Sienna, paint some darker water at the base of the harbour wall and around the waterline of the trawler, using a 12mm (½in) brush moved sideways. Leave some unpainted horizontal marks for ripples on the water.

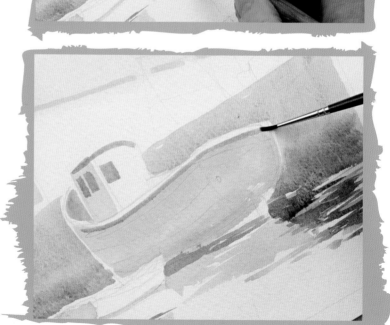

10 Apply some detail to the cabin and bow of the trawler, with grey windows and roof shadow, and Raw Sienna for the inside of the bow, and around the top edge of the hull. Use a no. 2 round brush for this.

11 To make the trawler look more solid, paint the side of it with another layer of green, making this darker near the waterline by adding a touch of Burnt Sienna. Use the same colour to add a few horizontal reflections underneath the hull.

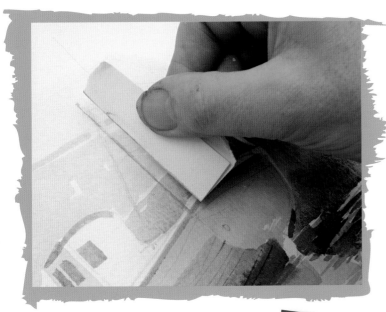

12 The last bits to be added are the masts and ropes. Apply these with a small piece of watercolour paper with a straight edge. Paint a little Raw Sienna, slightly diluted, on to the straight edge and immediately press on to the painting where you want the mast to be. Curve the paper between your fingers, and push it on to the painting to apply ropes in the same way. As always, practise these techniques on some scrap paper first! Now, sit back and see if your painting needs a few finishing touches. I added a few lobster pots on the quayside and painted some little flags on them. I also put a thin line on the rowing boat.

After I finished this demonstration painting I realized that some red was needed, so added a thin Cadmium Red line along the edge of the trawler. You may like to do the same, or choose another colour.

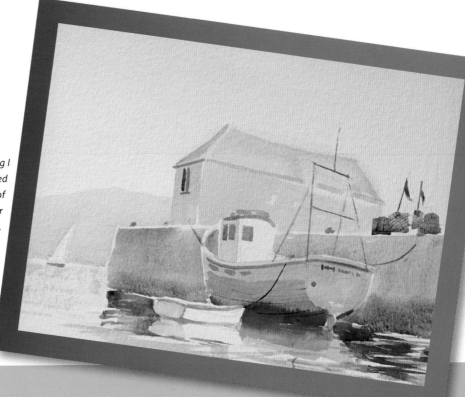

TRANSPARENT AND OPAQUE

This is a very similar view, this time using acrylic like an oil paint. I have included this image to show the versatility of acrylic paint when compared to other mediums; there is nothing else that gives you so much scope!

SUBTLE OR BOLD

The opaque technique version shown here is something that we will be doing later in the book, and it shows how different the painting looks from the transparent method that we've just been using. When painting acrylics in an opaque way, white is used to make colours lighter, and the paint is applied more thickly. Brush strokes are applied so that they show clearly, and the whole painting looks textural, with more impact.

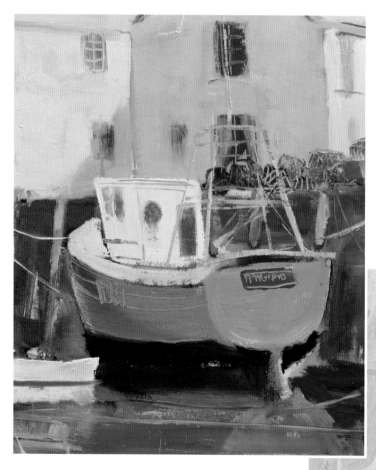

Using thick slabs of opaque colour can be very effective for applying reflections, and it is great fun to let a large brush slide big strokes over the painting surface.

See how the watercolour technique looks softer and more subtle than the opaque? With practice and experience it is possible to choose the technique to suit the mood or atmosphere that you want to portray.

KEEPING IT SIMPLE

This painting of boats at Newlyn was painted on tinted card, while I was sitting on the harbour wall. Where to start with a complex scene like this? Well, in this case, I started from the middle and worked out. I just painted the shapes as I saw them, with no attempt to make sense of any of the scene. Anything I did not like or that did not work is hidden underneath the mount!

It is not often you get a chance to use large chunks of very bright colour, but a harbour scene like this one at Newlyn lets you use the strong vibrancy of acrylic paint to really good effect.

SUBJECT 3

QUICK & CLEVER
FLOWERS

Flowers are always popular to paint, and I am especially fond of daffodils and narcissi. Where I live there are masses of wild daffodils growing in the hedgerows; they herald the beginning of spring, with their optimistic colours of yellow, orange and delicate white singing out amongst the bare winter trees and drab landscape. The little group painted here live in a box outside my back door; I brought them into the studio to sketch a few shapes on to the watercolour paper, ready for masking and painting. This flower study will show you how contrast in tone and colour is a quick and clever way to emphasize shape, and will teach you an easy way to mask the daffodils.

YOU WILL NEED:
- 4B pencil and sketchpad
- 425gsm (200lb) watercolour paper and a board
- Paints: see swatches, right
- Brushes: Hake or 25mm (1in) flat, 12mm (½in) flat, no. 6 synthetic sable
- Watercolour palette, jars
- Masking fluid; scrap paper or thin card for applicator
- Dish or saucer for masking fluid
- Absorbent kitchen paper

Lemon Yellow

Cadmium Yellow Deep

Ultramarine Blue

Raw Sienna

Burnt Sienna

Sap Green

Permanent Rose

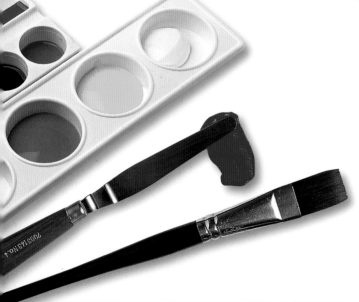

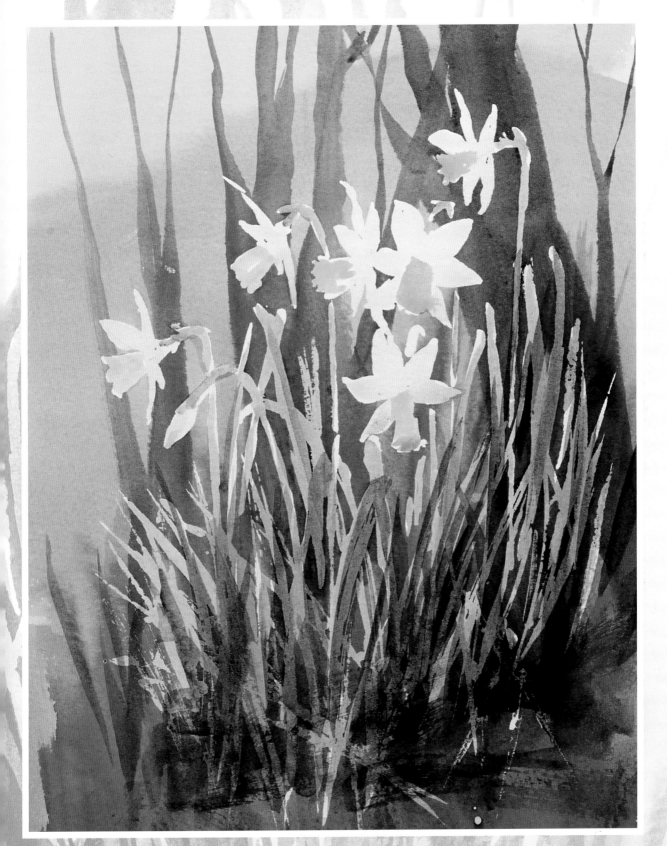

DAFFODILS *(SEE PAGE 78)*

We are now going to use masking fluid for the first time, to protect the white of the paper so that the daffodils stand out brightly against a darker background. The bare tree shapes behind need to be applied dark enough so that the tones work. Pages 76–77 show you how to simplify flower shapes so that they are easier to draw, and gives some really good tips about using masking fluid.

SIMPLIFYING FLOWERS

Most flower shapes have a symmetry, and these daffodils are based on a six-pointed star shape. Starting with that shape, looking full on, you can add petals and a trumpet. If the view is slightly from the side, the trumpet starts to look cylindrical. A side view shows the curved edges of the petals, and a cylindrical trumpet with the stem coming out the back.

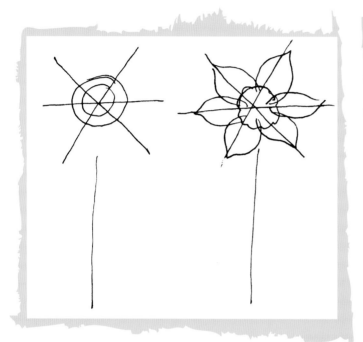

FRONT VIEW
A six-pointed star defines the petals when viewed from the front.

THREE-QUARTER VIEW
Seen slightly from the side, the trumpet appears like a cylinder.

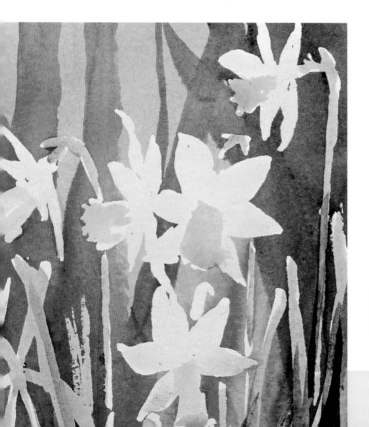

SIDE VIEW
A side view includes the stem, and shows the petals as thin curved shapes.

MASKING MADE EASY

Masking fluid is a liquid rubber solution. It will ruin brushes and can be tricky stuff, so needs quite a bit of practice. This is my brushless method. First, draw a simple daffodil shape, on watercolour paper; not too small, it is easier to practise big. Pour a little masking fluid into a dish or watercolour palette. Close the lid!

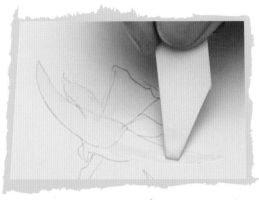

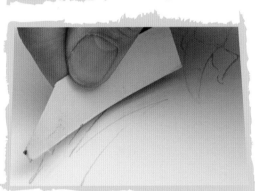

1 Use a piece of thin card, cut as shown, to dip into the fluid, then put a blob on the watercolour paper, in the centre of a petal. Spread this blob with the card, right to the petal's edge. Look carefully against the light to see if there are any gaps. Keep blobbing and spreading until the petal is covered. Apply more fluid in the same way, until all the shape of the flower is covered with no holes. If the masking fluid gets stringy, discard it, clean the piece of card (or if you are feeling rich, get a new bit), and continue.

2 Dip the straight edge of the card into the fluid, and push the edge against the paper to make thin lines like grasses. Check for accuracy, then leave to dry. To test if it is dry, touch the fluid with a piece of dry paper: it should not stick.

3 Using a hake or 25mm (1in) flat brush, cover the whole area with runny, dark paint, for maximum contrast. Set aside to dry completely. Then, use a gentle rubbing motion with a piece of kitchen paper to rub off the masking fluid.

You should now have a nice white flower that you can paint in a pale colour. You will probably find that your first go looks a bit scrappy; maybe your edges are not crisp, or there are dark bits on the petals. Do not worry! Practice will improve your results.

QUICK & CLEVER!

If the paper tears when you remove masking fluid, try using a heavier or smoother type of paper.

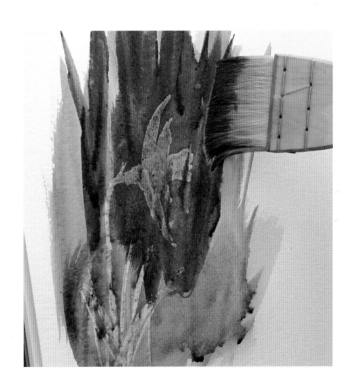

QUICK & CLEVER PAINTING
DAFFODILS

This attractive little study of daffodils uses contrast to make the flowers stand out. Remember to make the background dark enough.

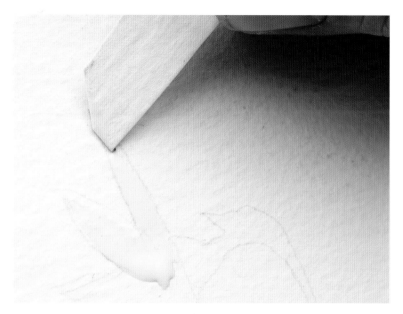

1 Draw the simplified flower group using a 4B pencil, ensuring that some of the blooms make contact or overlap each other. Pour a little masking fluid into a saucer: enough for five minutes' use. Always replace the lid! Cut a piece of stiff paper or thin card to make an applicator, and use this like a dip pen to apply and carefully spread the fluid, starting with the blooms.

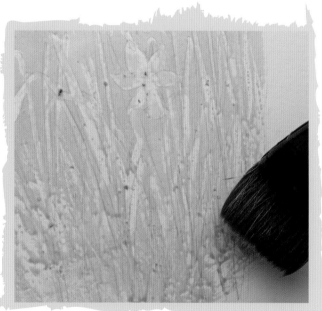

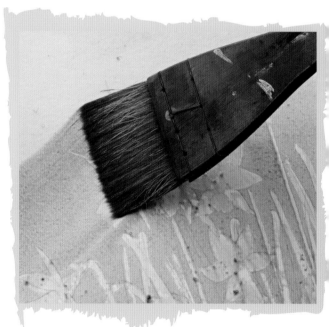

2 When all of the daffodils are masked, use the edge of a piece of paper to apply the fluid to the stems and leaves. Practise this first! If the fluid begins to dry and goes stringy, pour out some more, and use a clean piece of paper. Make sure this stage is completely dry; it will take thirty minutes or more. Then wash a dilute mix of Ultramarine Blue with a tiny touch of Permanent Rose on the whole area with a hake or 25mm (1in) brush.

3 Before this pale wash dries, use the same brush to paint a darker area from just above the flowers to the bottom, going over all the masked flowers and leaves. This will give the effect of a distant hill. The mix is made of Ultramarine Blue, a touch of Permanent Rose and a little Burnt Sienna. Let this dry for a few minutes.

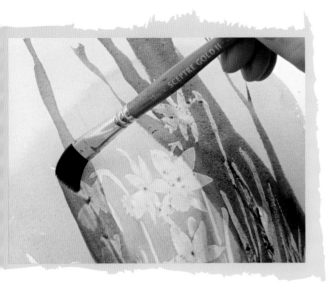

4 Use a mix of Sap Green, Burnt Sienna and Ultramarine Blue to apply some dark colour at the base of the image. Using the hake or 25mm (1in) brush on its edge, flick some angular lines up to give the impression of dark leaves. Do not worry about painting carefully; the masked areas will look neat, and you can paint over them. Leave this area to dry.

5 Take a dark mixture of Ultramarine Blue, Burnt Sienna and a touch of Permanent Rose, and apply some tree trunk shapes with a 12mm (½in) flat brush. Make the shapes irregular and crisscross the thinner branches one over the other. Use the brush on its edge for some of the branches. Try to cover all the daffodils with this paint, so that most have a dark background to define them. Merge the tree bases into the daffodil leaves.

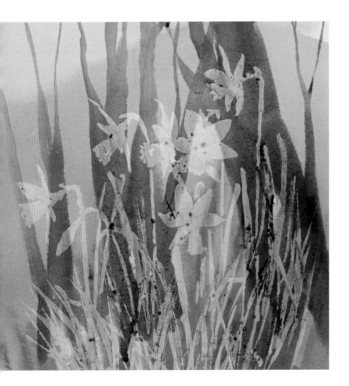

6 You are now almost ready to start removing the masking fluid, but wait! Sit back, and check that the background colour is really dark enough. Remember, the way the flowers will stand out is by contrast with a dark background. If yours is not dark enough, apply another layer right now, otherwise you will not get the tonal values right. Before moving on, everything must be quite dry; time for a cup of coffee!

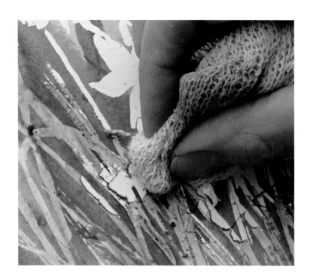

7 This is the magic bit! Take a large piece of kitchen paper or soft clean cloth, and carefully wipe across the paper with moderate pressure to remove the masking fluid. Rub across the stems and leaves, not along them. Take your time with this.

8 Use the 12mm (½in) brush to wash a dilute mix of Sap Green and Ultramarine Blue over the leaves and some of the stems. Add a touch of Lemon Yellow to vary the colour. Adding a further layer of the green near the bottom of the leaves gives a shadow effect.

QUICK & CLEVER!

Avoid the temptation to pull bits of the masking fluid off with your fingers; this may tear the paper.

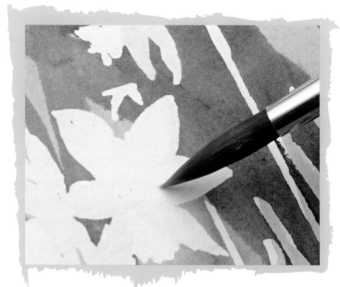

9 Take the no. 6 round brush and apply a pale, dilute wash of Lemon Yellow over the flowers. This must be kept very pale. You can add another layer later if it is not strong enough, but you cannot take it off if it is too dark! Vary the colour by adding a tiny touch of Cadmium Yellow Deep to the mix. Let this dry for a few minutes.

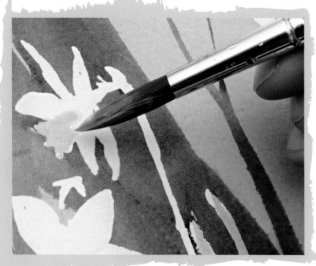

10 Deepen the yellow by adding a little more Cadmium Yellow Deep (not too much!), and paint the trumpet part of each flower. To impart a look of distance, some of the smaller flowers should be paler; use more dilute paint for these. Remember, it is better to add layers a little at a time to achieve the effect, rather than go for it all at once. Unlike watercolour, you will not disturb the underneath layers and get mixed colours looking like 'mud'.

11 Add Raw Sienna to the deeper yellow colour to darken it slightly, so that you can paint the inside of one or two of the trumpets. You do not need to paint them all, only the ones that are facing outwards. You can still use the no. 6 round brush for this; make sure you clean it well between each colour.

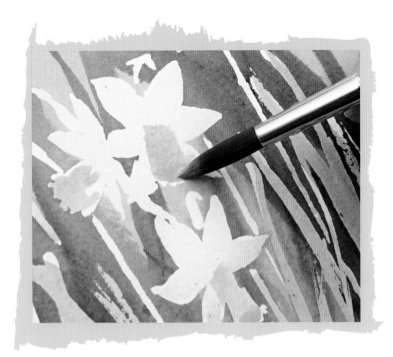

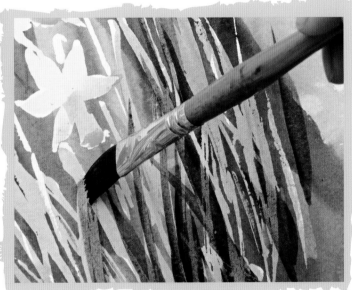

12 To finish, use the 12mm (½in) flat brush to flick in some greens, growing up from the bottom of the image. These can be quite dark, mixed from Sap Green and Burnt Sienna, but do not overdo it. Keep the image light. Using this masking method it is very easy, once the masking fluid is removed, to fill in all the white paper bits with dark colour, which kind of defeats the object if you think about it. You didn't do that, did you? Good!

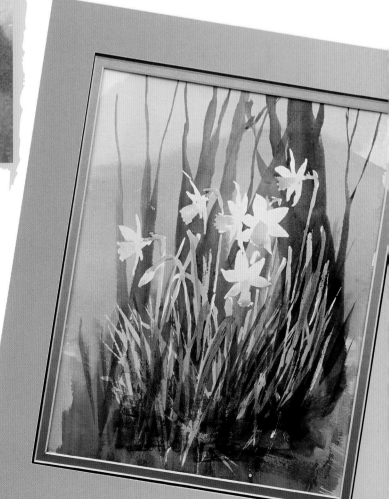

QUICK & CLEVER VARIATION
TRANSPARENT AND OPAQUE

This painting shows the versatility of acrylics; it is a very similar image of daffodils with an imaginary background. (They are quite famous, my little box of daffodils!) This time, the acrylic paint was applied thickly with oil-painting bristle brushes, using opaque, undiluted colour, with the addition of white paint, not water, to make colours lighter.

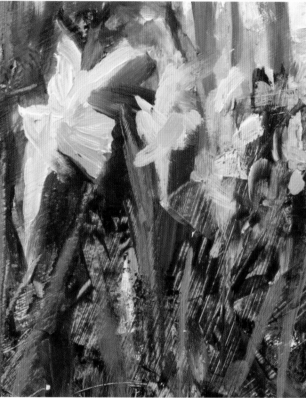

Strong, vigorous brushstrokes make this image vibrant and spontaneous, and the opaque use of the acrylics has an entirely different appearance to the transparent method below).

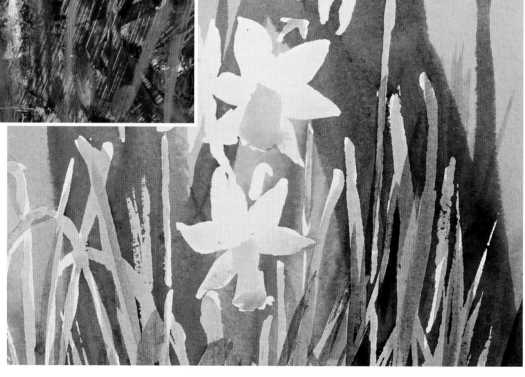

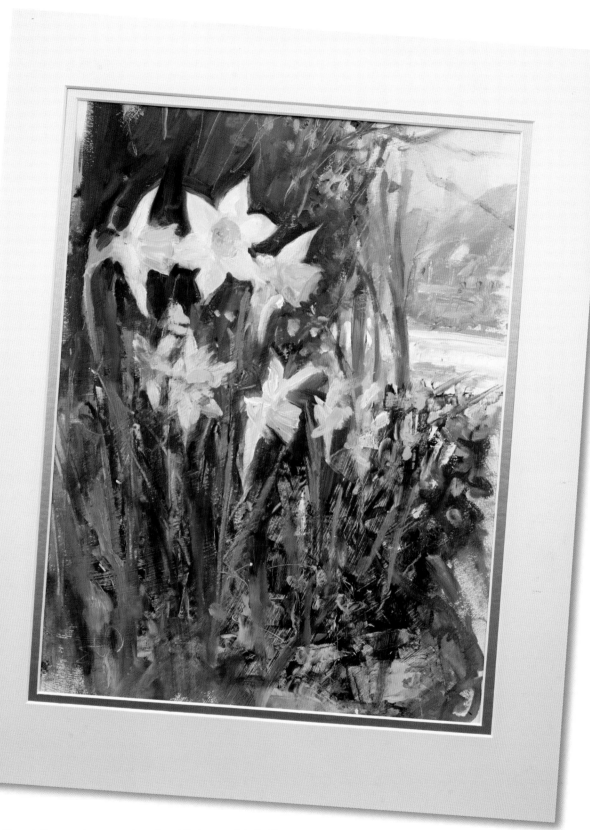

The painting was done on a piece of card that was painted with an acrylic gesso (a dense primer), tinted with Burnt Sienna to make a warm pale brown. This background colour shows through here and there, to add warmth and harmony. The next project, on page 84, is an opaque one, so have a go yourself!

QUICK & CLEVER
WINDMILL

In this section you will be using white to lighten a colour instead of adding water, using acrylics opaque and undiluted, more like an oil paint, and sometimes using oils-type bristle brushes.

The technique entails 'blocking in', which means covering the whole of the board in shapes and basic colours, then going over it to modify these colours and add detail. For this reason it is usual to start by drawing the shapes with a big brush; you can easily make any changes by painting over with an opaque undiluted layer as the painting progresses, using smaller brushes as you work towards the end.

Before you start, let us look at two associated elements: perspective and skies. These appear in many landscape paintings.

YOU WILL NEED:
- 4B pencil and sketchpad
- Heavy card, about 3mm (1/8in) thick
- Paints: see swatches, right
- Brushes: no. 12 flat synthetic bristle brush, no. 10 synthetic filbert, no. 6 round synthetic sable, 12mm (1/2in) flat, 50mm (2in) household paintbrush for priming the board
- Acrylic stay-wet palette
- Acrylic white gesso
- Acrylic matt medium
- Piece of scrap card with a straight edge; a couple of small rulers or other straight edges

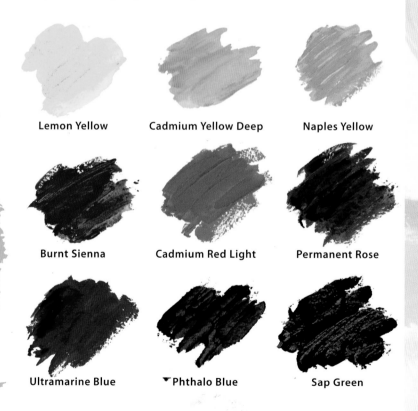

Lemon Yellow Cadmium Yellow Deep Naples Yellow

Burnt Sienna Cadmium Red Light Permanent Rose

Ultramarine Blue Phthalo Blue Sap Green

Titanium White

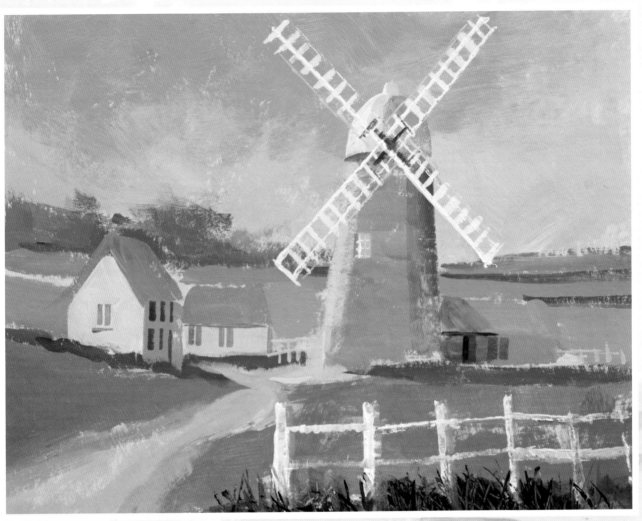

WINDMILL (SEE PAGE 90)

If you have been using the transparent method up to now, you will find the feel of thicker paint a bit strange to start with, but do not be tempted to water it down too much; it's a common mistake. Start painting with a big brush, and avoid getting fiddly. All paintings that contain buildings need to use perspective, and pages 86–87 show you how to transfer angles on buildings from a photo to your painting. You will also find it useful to practise painting skies, and these are explained on pages 88–89. Remember, practice makes perfect!

PERSPECTIVE

I bet the word 'perspective' brought you out in a cold sweat! Perspective, yuk. I have been teaching art for more years than I want to admit to, and I know what frightens people about this: maths, measuring, and memorizing. Good news! You do not need any of them for my perspective method. All you need are two straight edges; I am using a couple of pencils.

First, you will need to stand, so that you can look down on the drawing. Put a photograph of the building you want to draw beside your pad, making sure that the edge of the photo is touching the edge of the pad.

1 Put a straight edge along an edge on the building in the photo. I have started with the edge of the roof. Now, place your other straight edge on the paper, where you want to draw the building, *so the two straight edges are parallel*. The pencil on the photo is at the same angle as the pencil on the pad. Can you see that? Draw a line at this angle on the paper.

2 Next, put your straight edge along another part of the roof. Again, looking down from above, place your second straight edge *parallel to the one on the photo*. Make sure you do not move the photo or the pad. Can you see that my pencils are parallel? Excellent! Now draw that angle on the paper.

3 I shall do the smaller end section of roof next, and by then you will have the hang of it. *Can you see the pencils are parallel?* Well done.

'OUT OF DOORS' METHOD . . .

If you are sketching a building outside, hold a pencil in front of your eyes, horizontally, at arm's length. Close one eye, and line up a feature on the building so it is behind the pencil. Now ask these questions. Does the feature appear to slope? If so, which way does it slope down: left or right? How much does it slope down: a little, medium, or a lot? Then, having decided, draw your line on the paper according to what you have observed.

4 I have done a bit more, using the method to get the angles of the tops and bottoms of the windows, and the top of the wall. Now find a photo of your own, and follow the steps for your own image. You will see that it is not as difficult as you probably first thought.

CLOUDS MADE EASY - TRANSPARENT

First, here is how to paint a sky using the transparent technique, on watercolour paper using watercolour brushes. In each case, the landscape is applied afterwards. It is worth practising these sky studies; a well-painted sky will enhance your paintings and impart mood and atmosphere. All the great landscape artists have made paintings of clouds for practice, so you are in good company!

SUBJECT 4

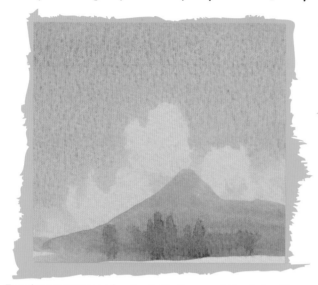

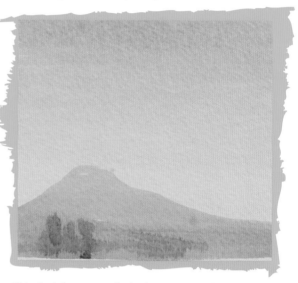

To paint summer cumulus clouds like these, wash the sky in with dilute Ultramarine Blue, using a 25mm (1in) flat brush, and immediately use a piece of absorbent kitchen paper to lift out the cloud shapes. Use a different part of the absorbent paper for each cloud. Each time you touch the paper you make a cloud!

This sky is hazy near the horizon. Mix a puddle of Ultramarine Blue in a well in your palette; and in another well, put a pool of water. Wet the paper slightly. Start putting on a wash; with each stroke you make add a little water to the puddle, making it paler nearer the horizon.

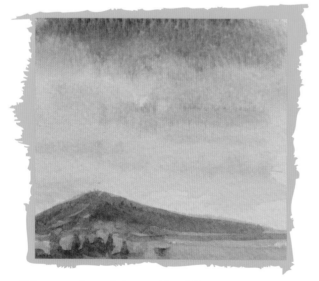

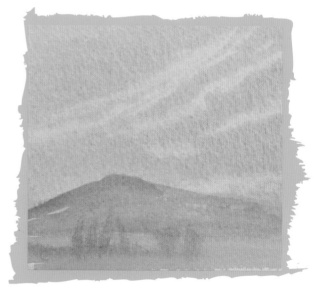

This stormy sky needs three puddles of dilute paint: an Ultramarine Blue and Permanent Rose mix (making violet); a Naples Yellow; and a very dilute Cadmium Red Light . Put a brushstroke of violet across the top, add a stroke violet and Naples Yellow mixed, next to it, a brushstroke of Naples Yellow on its own, then a stroke of red across the Naples Yellow. Lift out some clouds while wet.

These little wisps of cirrus cloud coming over the hill are easy to create. Wash in a pale blue, and with the edge of a folded piece of absorbent paper, lift out some linear marks.

CLOUDS MADE EASY - OPAQUE

This is the opaque technique, on board primed with gesso tinted with a touch of Burnt Sienna. Use bristle brushes for these skies. A touch of retarding medium added to the paint slows the drying for blending. All the landscapes are added later.

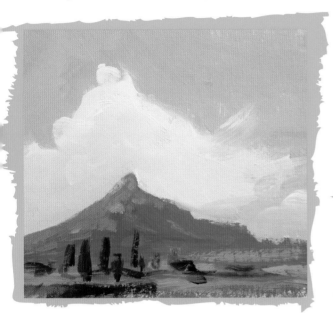

Bold, towering cloud shapes can be painted with a medium size bristle brush and some Titanium White with a touch of Naples Yellow. Mix a little Ultramarine Blue with some Titanium White, and paint around the cloud, working top down. As you go, add a bit more white with a tiny touch of Phthalo Blue for the sky lower down, near the horizon.

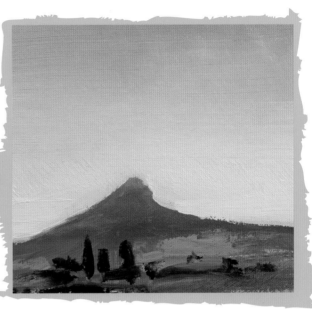

This hazy sky has white and a little Ultramarine Blue at the top, then a touch more white is added, with a tiny amount of Phthalo Blue, so it becomes paler and cooler towards the bottom. Paint across in strips, working quickly, then use a fan blender brush diagonally, softening edges so there is a gradual colour change.

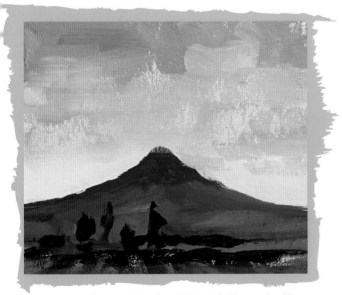

These stormy colours are Titanium White with Ultramarine Blue and Permanent Rose and a touch of Burnt Sienna for the top, with white, Naples Yellow and a touch of Cadmium Red lower down. The clouds are brushed in vigorously with no attempt at blending.

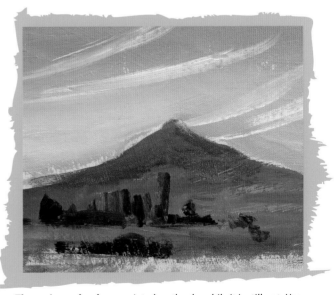

These cirrus clouds are painted on the sky while it is still wet. Use a touch of retarder. The sky is created from Titanium White, Ultramarine Blue and a tiny touch of Phthalo Blue. More white is added to the sky further down. The clouds are applied with a flat bristle brush on its edge, using white with a touch of Naples Yellow.

QUICK & CLEVER PAINTING
WINDMILL

Remember that you are now using white paint to make colours lighter. This may feel strange at first, but one of the benefits of working this way is that the paint is opaque, so you can paint over your mistakes! You may find that your colours dry a tiny bit darker, but this varies from manufacturer to manufacturer, and it is something that you will soon get used to.

1 Prime a board with white gesso tinted with a little Burnt Sienna, and allow to dry. Make a dilute mix of Ultramarine and Burnt Sienna and, using a no. 6 round brush, draw in the simplified shapes. Do not worry about runs or dribbles; this is an opaque method, so these will disappear later. From now on in this book, there is no more dilution; all the paint is thick and heavy!

QUICK & CLEVER!

If you finish this painting and feel you need to brighten up any areas, just re-paint with lighter colours to get the desired effect.

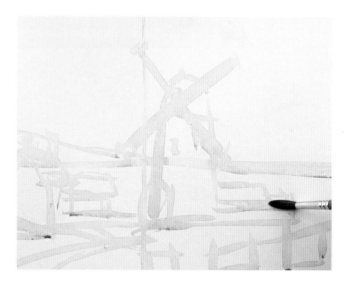

2 Now, squeeze about 2.5cm (1in) of Titanium White onto the palette, add a touch of Ultramarine Blue, a tiny touch of Permanent Rose, and a spot of Burnt Sienna. Mix together using a no. 12 flat bristle brush, without any water, then use this colour to block in the sky, which should be a pale, warm blue-grey. Leave plenty of brushstrokes showing. Do not worry about painting too carefully around the windmill; you can paint over any unwanted areas of colour later.

3 Take some more Titanium White, add a tiny touch of Phthalo Blue to it, and paint over the lower part of the sky, making sure that this is paler than at the top. Use bold, vigorous brushstrokes. Put a touch more Phthalo Blue into the mix, with a hint of Lemon Yellow, and Burnt Sienna, and paint the horizon line. Add some white and Lemon Yellow to this for the distant fields. Do not clean the brush!

4 Use the paint from the last step and add a touch of Sap Green and tiny amount of Burnt Sienna. Paint the nearer grass areas. Let the brushstrokes show, and do not make everything smooth; the surface should look quite textural. Work over the area near the bottom of the painting with a touch of Cadmium Yellow Deep added to the same mix. Leave the path area unpainted.

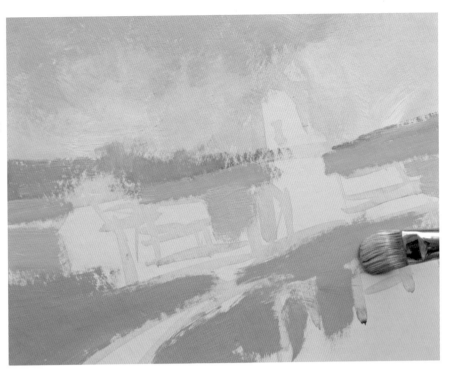

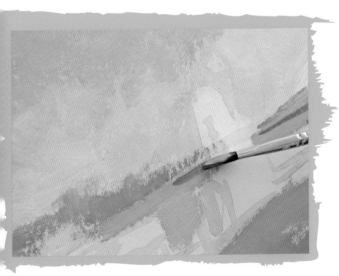

5 Change to a no. 10 filbert brush (which you will use for the next five stages), and darken the green on the palette with a little Ultramarine Blue and Sap Green. Use the brush on its edge to apply distant hedges, flicking the brush up here and there to make simple little tree shapes. Practise these on scrap paper first! Add a touch more blue to this green and paint some shadow lines under the place where the windmill and buildings will be. Now let the painting dry; clean your brushes, and go and have lunch, you have earned it!

6 Use a mixture of Titanium White and Burnt Sienna, with little touches of Cadmium Red Light and Naples Yellow, to make the brick colour for the windmill. To paint the side of the windmill, hold a piece of paper where you want the edge to be, and run a brush loaded with paint down it, along the edge of the paper strip. Then do the same for the other side using a clean piece of scrap paper; job done!

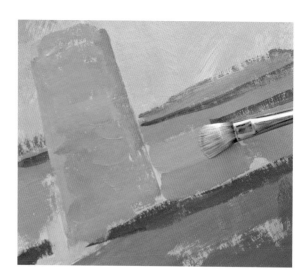

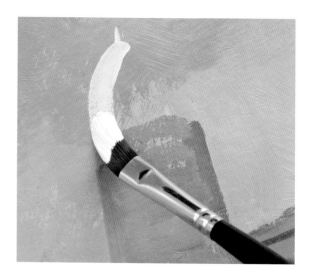

7 Now you have established the edges, paint the rest of the mill building, making the strokes horizontal to imply brickwork. Add the shed on the right in the same way. The roofs of the houses on the left are added with the brick colour, plus a touch of Naples Yellow. Naples Yellow and white make the walls of the buildings. Add a touch of Ultramarine Blue plus a tiny spot of Permanent Rose to this creamy colour for the violet-grey shadows and the roof on the right of the mill.

8 Use pure Titanium White to paint the left side of the 'dome' of the mill, with a touch of Ultramarine Blue and Burnt Sienna added to make a pale grey for the shadow side. This will support and contrast with the sails when they are applied later. A darker grey line, applied beneath the dome, attaches the dome to the brickwork. Allow to dry.

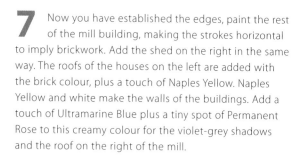

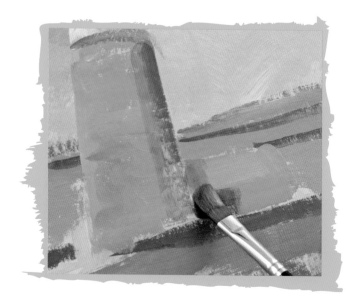

9 To darken the shadow side of the mill and create a rounded look, mix a tiny touch of Ultramarine Blue, Permanent Rose, and Burnt Sienna, with some acrylic matt medium, to make a glaze; like a coloured varnish. Test it for darkness and colour on some scrap paper before using it. Apply down the shadow side of the mill, and on the roof of the shed. The shapes of your earlier brushstrokes should all show through.

10 Mix tiny touches of Burnt Sienna and Cadmium Red Light with Titanium White, and paint a strip of this down the left-hand side of the windmill and on the path. Make a glaze with Lemon Yellow and acrylic matt medium, and brush this over the greens just behind the buildings (but not the distance). Add a touch of Cadmium Yellow Deep to the glaze, for the foreground area.

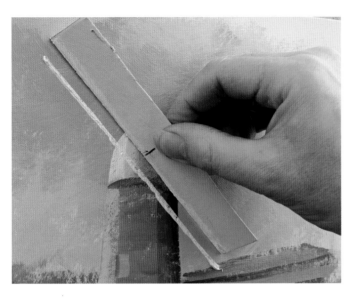

11 Now for detail! Make a grey with Ultramarine Blue, Burnt Sienna and Titanium White and, using a 12mm (½in) flat brush, create little windows and doors in the buildings. Add a pale grey window on the mill. Take a straight piece of card the correct size and paint the edge white. Apply this to the mill, where the sail will be. Put a parallel one next to it, then two more at right angles to these, re-applying white paint to the edge of the card each time. Use the 12mm (½in) brush to put in the cross-pieces, and add a dark grey cross in the centre.

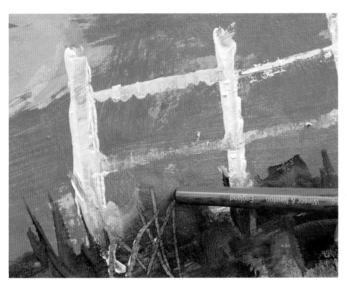

12 Finishing touches! Use a smaller piece of card to apply the fence posts in white, and add some dark greens below them with a mix of Sap Green and Burnt Sienna. While this area is still wet, use the handle of the brush to scrape out some grasses in the foreground. Add a few little pink touches to the track, then sit back and admire your work. This has been a good exercise in using opaque acrylics, as well as a bit of glazing. I hope you liked doing the painting as much as I did.

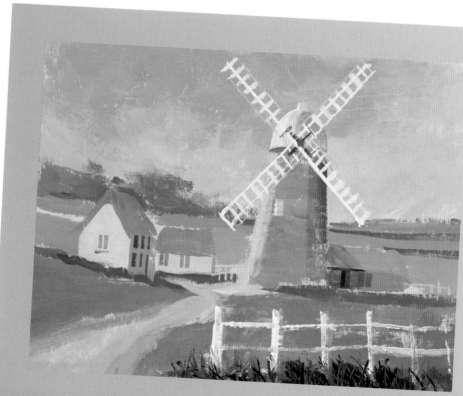

QUICK & CLEVER VARIATION
TRANSPARENT AND OPAQUE

Because acrylics are such a versatile medium, you can decide to do a painting in the watercolour (transparent) way, or using the oils (opaque) method. As you gain experience by completing the projects, you may like to try using a different method from the ones shown. If you do, you will be able to compare the two techniques and see which you prefer using, and which one you like the look of.

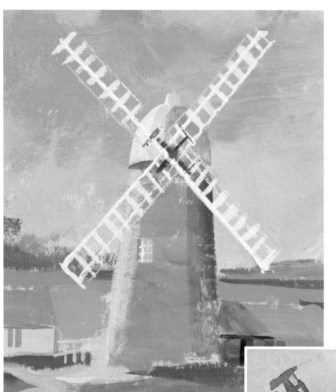

As you can see here, the methods give quite different effects. The opaque version that you have just painted (left) has a brushstroked, painterly look, where individual marks of the brush show. The base colour of the board shows through here and there, giving a unifying effect. The overall look is more textural, with an oil-painted look. Compare this with the transparent image below and opposite.

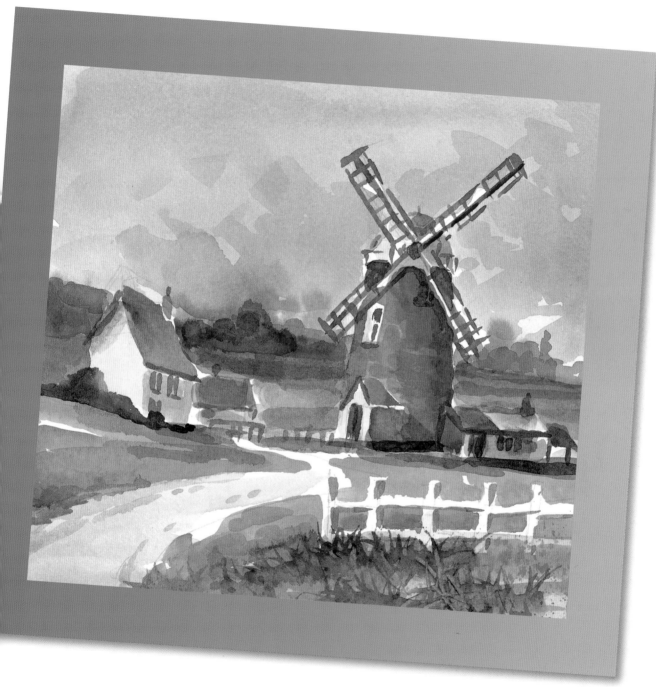

You can see how the different techniques produce different effects. This watercolour technique version, painted on 425gsm (200lb) watercolour paper, uses washes and little touches of transparent colour that allow the white of the paper to show through. It retains a vibrant quality because, unlike watercolour, the acrylic layers do not disturb the ones underneath. So it is possible to build an image up with many layers without getting muddy colours. The paint washes on well, especially if a flow improver is used in the water.

SUBJECT 5

QUICK & CLEVER
MOUNTAINS

The painting technique used here is all about strong textural impasto marks, edges of juicy paint, and vibrancy. To begin with you need to learn how the knife works. To get the benefit of the exercises practise using your painting knives, working through the techniques until you feel comfortable.

Knife painting is an oil-painting method that depends on how you pick the paint up, and how the blade slides across the canvas. It is important when using a knife that the paint does not dry too quickly; always add a touch of acrylic retarder to every mix, following the instructions on the tube.

YOU WILL NEED:
- A canvas board, about 30 x 40 cm (12 x 16in), and something to prop it up (a book will do, but not this one!)
- Paints: See swatches, right
- Retarding medium
- Knives: Small, medium and large leaf-shaped painting knives
- Brushes: no. 12 flat bristle brush
- Absorbent kitchen paper to wipe knives as you work

Naples Yellow

Cadmium Yellow Deep

Ultramarine Blue

Phthalo Blue

Sap Green

Burnt Sienna

Cadmium Red Light

Titanium White

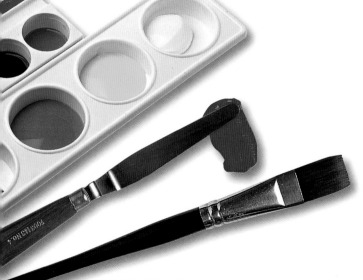

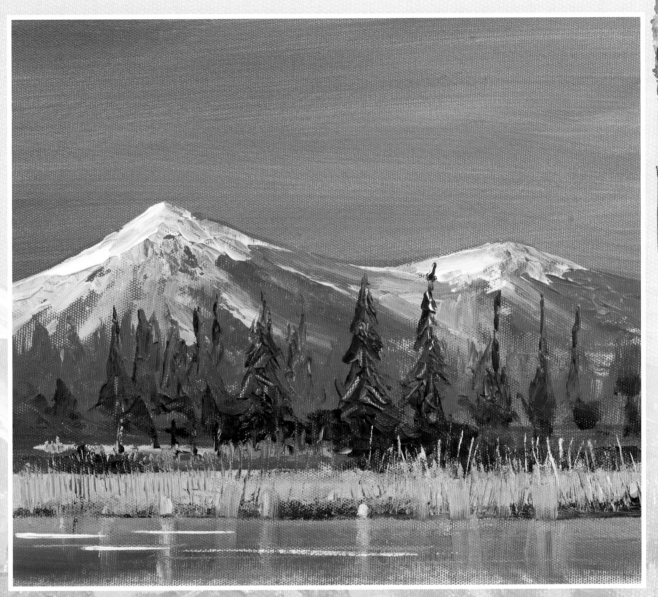

MOUNTAIN SCENE (SEE PAGE 102)

This is an image that uses the expressive quality of the knife
to good effect, and has a chunky, slightly angular look.
Some subjects seem made for this kind of painting, and
mountains are one of them. Pine trees, water, and boulders
are also ideal topics. You will find some practical mark
making exercises on the next four pages, and it would be
good to work through these so that you are full of knife
painting confidence when you start the project.

KNIFE MARKS AND TEXTURES

A painting knife is excellent for making strong textural marks. Practise some of these using different sizes of knife. The technique works best if the paint is applied with a spreading action on to a wet layer of paint beneath. This helps the knife to slide. Do not use the technique unless you have some retarding medium, because the paint will dry too fast.

SUBJECT 5

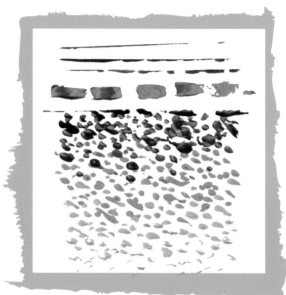

USING THE EDGE OF THE KNIFE
Use the knife on its edge to create expressive ridges for mountains, adding more paint with each ridge, like this.

USING THE TIP OF THE KNIFE
Using the tip of the knife you can make very delicate little dots, rectangles, and lines. Practise some of these.

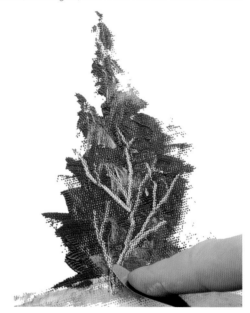

SLICING
Slicing the edge across wet paint removes some of it and exposes the colour underneath, ideal for reflections!

SCRAPING
Scraping back through a layer with the tip is useful for applying branches, especially when the colour underneath is darker or lighter.

PAINTING TREES WITH THE KNIFE

Making this sort of tree shape is simple with a medium size knife. Make a few practice strokes with the knife first, to get used to the feel of it, and try various marks. Try to make texture as you paint; texture is part of the charm of knife painting.

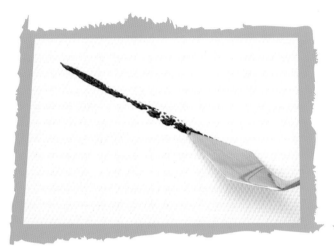

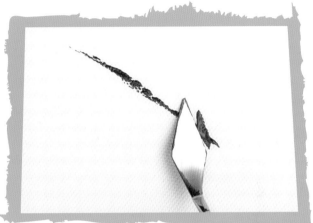

1 First slide a ridge of paint on to the edge of the knife. Then, holding the edge against the board, touch the knife to make a vertical line for the trunk.

2 Starting from the top, apply a little ridge of paint at an angle to the trunk.

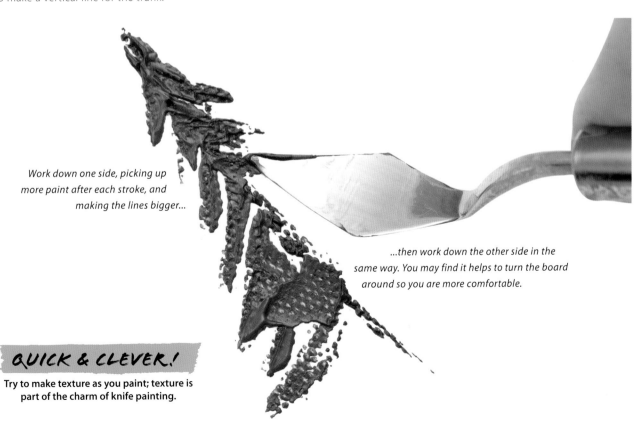

Work down one side, picking up more paint after each stroke, and making the lines bigger...

...then work down the other side in the same way. You may find it helps to turn the board around so you are more comfortable.

QUICK & CLEVER!

Try to make texture as you paint; texture is part of the charm of knife painting.

WATER AND REFLECTIONS

Creating water and reflections works well with a painting knife. Practise some of these effects. Ripples on water are best applied as thin lines; try to avoid too many blobs and make sure that the lines are horizontal, otherwise the water will look like it is running downhill.

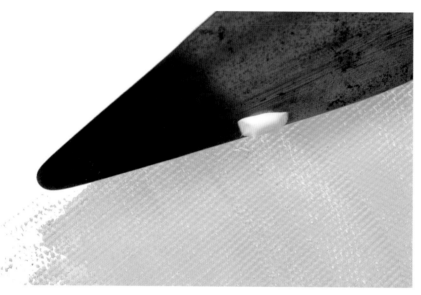

QUICK & CLEVER!

A few little ripples put on top of some dragged reflections really look quite watery and give a good effect. And it is easy to do!

1 Paint a blue or other watery base colour with a big brush. Before this dries, pick up a spot of paler paint on the edge of the knife.

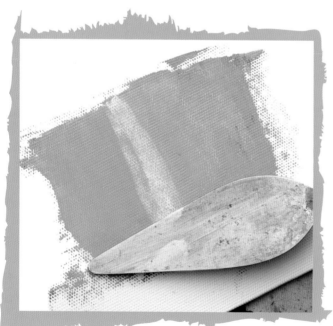

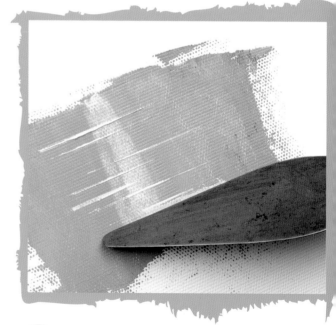

2 Slide the knife down across the base colour, to make a simple reflection. Try and make this a vertical mark; it looks more natural.

3 Scrape a thin ridge of paint onto the edge of the knife, and apply a few little marks across the previously painted reflection to show ripples.

STONES AND BOULDERS

Many landscapes need some rough textural shapes in the foreground to give interest and stability. Stones and rocks, whether on the ground or made into walls, impart a solid feel, and using a knife adds texture and makes rocky shapes look believable.

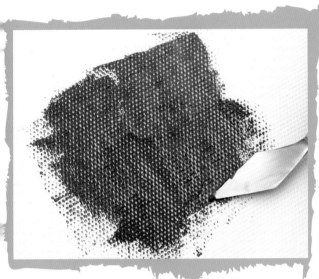

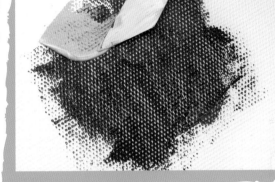

1 To create stones and boulders, use a knife to apply some base colour, darker than you want the rocks to be.

2 Apply a paler colour on top, taking care to make the shapes irregular. Streaks and texture all help the effect.

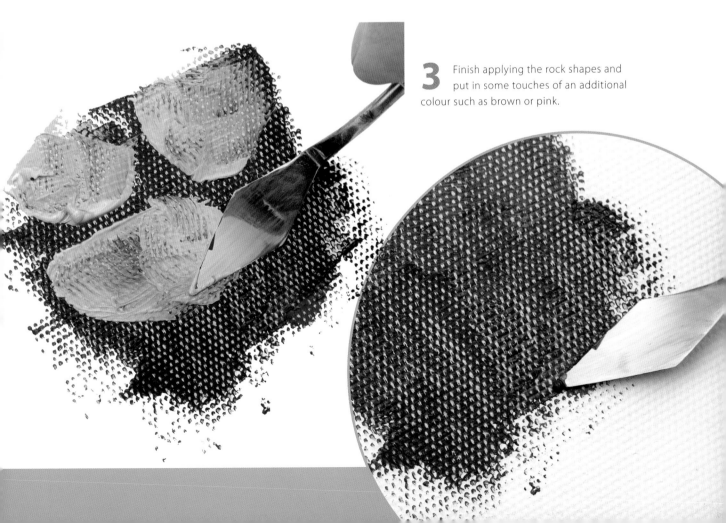

3 Finish applying the rock shapes and put in some touches of an additional colour such as brown or pink.

QUICK & CLEVER PAINTING
MOUNTAIN SCENE

Now you have had a bit of knife practice, have a go at this mountain scene. This type of scene is ideal for the knife, with plenty of texture and linear marks. Snowy mountains, in particular, work well. Do not forget to add a little retarding medium to the paint, otherwise it will dry too quickly.

1 Make a mid cool blue with Titanium White, a little Ultramarine Blue, and a touch of Phthalo Blue. Mix in some acrylic retarding medium, following the instructions on the tube. Using a no. 12 bristle brush, thickly paint the top third of the canvas board, then put a touch of Burnt Sienna into this colour and paint some irregular mountain shapes. Add a little more Burnt Sienna and a touch of Phthalo Blue and paint a simple zigzag line to show the area where the trees will be.

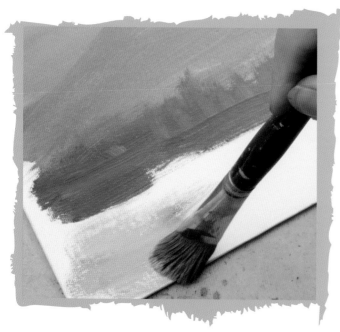

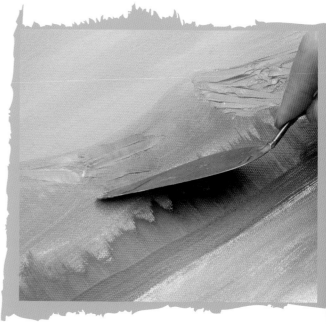

2 Use Titanium White, a bit of Ultramarine Blue and a touch of Burnt Sienna and block in the water; this should be lighter than the trees. Do not dilute the paint or worry about accuracy; everything except the sky will get another layer of paint. All you need to get right at this stage is the water line; make sure it is more or less horizontal.

3 Take Titanium White, with a little Ultramarine Blue and Burnt Sienna to get a mid grey, a bit darker than the sky. Scrape some of this mix on to the large knife, and apply it on the right-hand side of the mountain peaks, like spreading butter. Start by holding the knife parallel to the edge of the mountain, and spread; do not scrape or push the paint. Use the ridges made by the knife to show the shape and texture of the mountain.

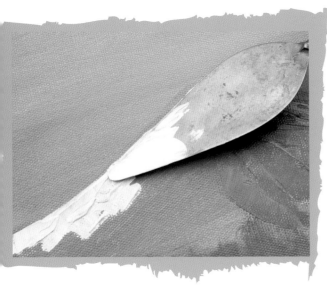

4 Paint the sunlit side of the left mountain using a very pale grey made from Titanium White and a tiny touch of the grey used in step 3. This time, angle the blade of the knife the other way, parallel to the side of the mountain peaks. Add a tiny, tiny touch of Phthalo Blue to the pale grey, and apply a few touches of this to the darker, right, side of the mountain. This looks like snow in shadow.

5 Put more pale grey on to the knife, and apply the right-hand ridge, moving the knife down and to the right in one movement. If the paint coming off does not cover properly it is a sign that you are not using enough paint. Remember to add a little bit of retarder to the paint as you mix, to stop it drying too quickly, but always read the label for the correct amounts.

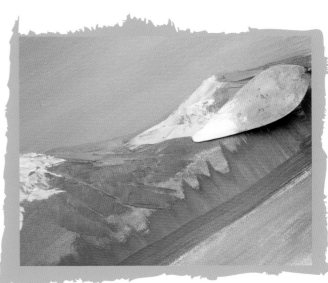

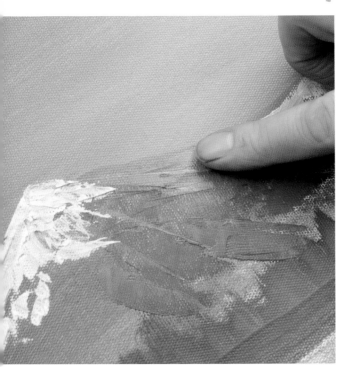

6 Before the paint starts to dry, blend a little of the mountain colour together, with your favourite painting finger. If you do not like the idea of getting paint on your hands, you could use rubber gloves; some of them have interesting patterns on – you may invent a whole new painting technique!

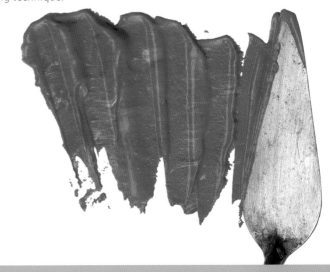

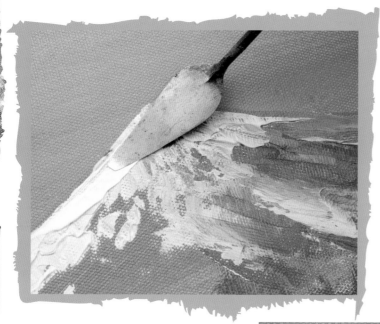

7 Using a smaller (medium) knife, paint a touch of Titanium White with a hint of Naples Yellow on to both peaks where they catch the sun. This area must look very bright, otherwise the effect is lost. Keep these brightest areas small and neat.

8 Before the mountains dry, take your artist-quality finger and blend around the lower parts, especially on the shaded side, drawing the wet paint downwards. This will impart a soft snowy look and contrast well with the trees that are coming next. Before moving on, sit back and admire your mountains. Pretty good!

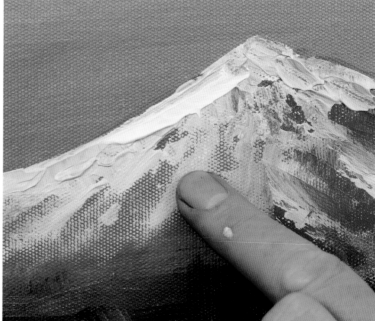

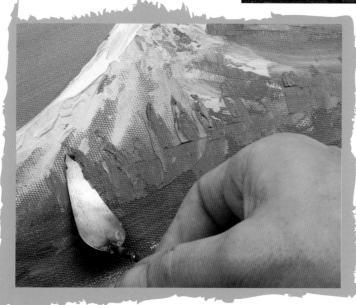

9 With a mix of Sap Green, a touch of Pthalo Blue, a little Burnt Sienna and some Titanium White, apply the line of trees in a mid green colour, using vertical strokes of the medium knife. These trees are at the back, behind the darker ones that will go on top later, so they should not be dark, and do not need to be too tidy.

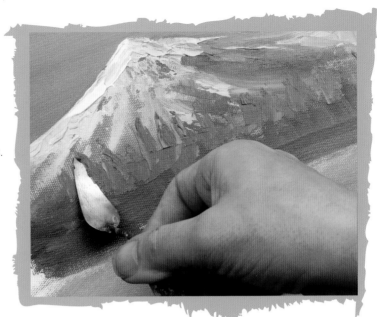

10 Continue working across the image, making the trees various sizes and shapes. Use the knife with the blade flat against the board, and tilted slightly, to vary the texture of the stroke. Save some of the lighter green.

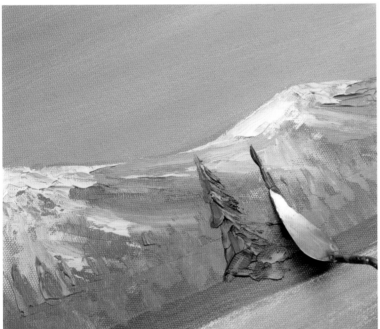

11 Mix Sap Green, Burnt Sienna, and a touch of Ultramarine Blue, and lighten it by adding some light green from step 10. Apply darker trees on top of the light ones, making sure that some of the lighter ones show through. Because these dark trees are nearer, they need to be slightly taller.

12 Using a small knife, drag some of the paint down on each side of the dark trees to create the look of branches. Mix some deep darks with Sap Green and Burnt Sienna, and apply these carefully with the small knife on the sides of trees where there would be shadows.

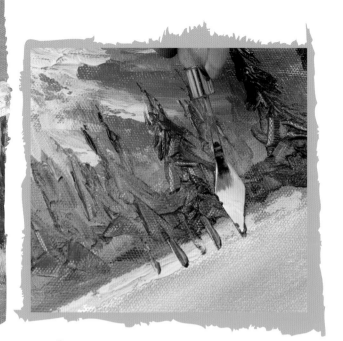

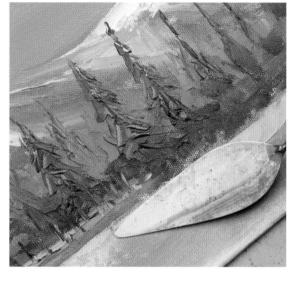

13 Paint a thin line of Naples Yellow at the base of the trees with the medium knife, to look like sunlit ground. Now use the small knife to apply some of the dark colour to give the shapes of trunks, by scraping a ridge of paint on to the side of the knife, then putting the edge vertically, and moving it slightly sideways. Run a thin dark green shadow under the trees.

14 With the large knife, spread a mix of Naples Yellow and Titanium White in a wide horizontal line beneath the line of trees. Add Burnt Sienna, and put a dark brown line where the water's edge is going to be. To get a nice crisp line for the water line, you may find it is easier to turn the painting upside down and work back into the Naples Yellow.

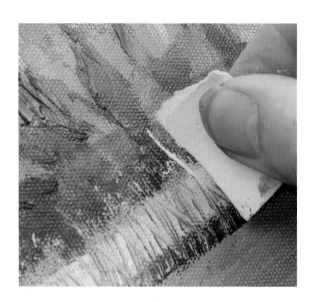

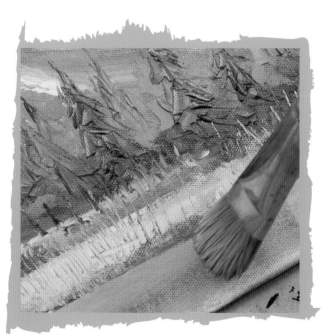

15 Take a piece of thin card and scrape a little Naples Yellow onto its edge. Touch this edge along the top of the yellow area and into the trees to give the effect of reeds. Wipe the paper if it picks up green, or use a new piece. Add to the reed effect by scraping vertical marks with the tip of the small knife.

16 Put the knives down; it is time for a bit of brushwork! Use Titanium White, Ultramarine Blue, and a touch of Phthalo Blue, for the water. Paint this with the no. 12 bristle brush. It can be quite streaky, as long as the streaks are horizontal. Do not let any streaks be diagonal, or it will look like a waterfall.

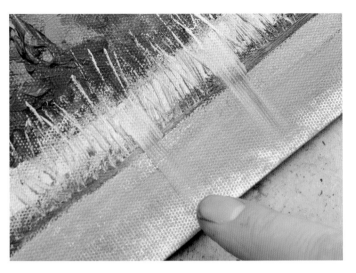

17 While the water is still wet (if you see what I mean!), use a finger to pull some of the Naples Yellow down into it to make the reflections. If the yellow is too dry, mix up a little more for this. Continue making several of these reflections, but do not put in too many, or make them evenly spaced, or it will look wrong. A few touches of an orange colour (mixed from Cadmium Yellow Deep and a touch of Cadmium Red) looks good among the reeds.

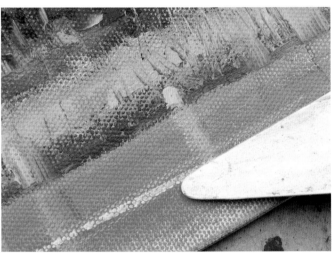

18 Finally, scrape a ridge of Titanium White on to the edge of the large knife, and, holding this absolutely horizontal, touch the edge on to the water here and there to make ripples. Like the reflections, it is best to restrict this technique to a few marks, otherwise it will look too busy.

Now, sit back, and admire your knife-work. It is a technique all of its own, and this has been a good introduction to it. I hope you enjoyed it. Well done!

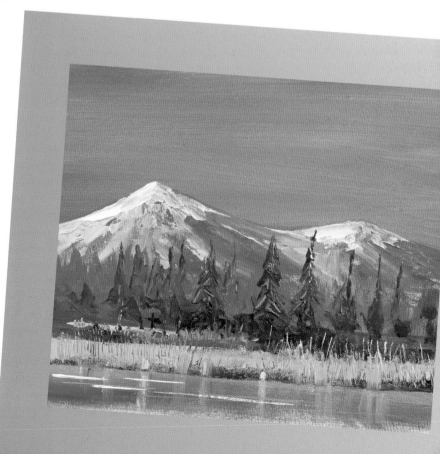

SUBJECT 6

QUICK & CLEVER
VENICE

This is a warm sunlit image of a unique place. There have been so many paintings of Venice that it is easy to fall into a cliché; gondolas, the lagoon with the domes in the distance, the Grand Canal.... So I have deliberately chosen a quiet backwater with a few people passing by. The painting is blocked in to start, with the opaque method used for most of it. The majority of the colours are from the warm side of the spectrum: pinks, yellows and pale oranges. Before you paint, why not try to imagine you are standing on the side of a small canal, beside a little café in the sun? Get a bowl of Italian ice cream, or a good cup of coffee, and put some opera on the CD player. There, that's it. Now you are getting into the atmosphere we'll start painting!

YOU WILL NEED:
- Pieces of thick card (3mm, ⅛in or so), about 30 x 40 cm (12 x 16in)
- Paints: See swatches, right
- Brushes: nos 6 and 12 synthetic bristle brushes, no. 6 round synthetic sable, 12mm (½in) flat
- Acrylic gesso to prime the board
- Matt medium for glazing
- Acrylic stay-wet palette

Lemon Yellow

Naples Yellow

Cadmium Red Light

Burnt Sienna

Ultramarine Blue

Phthalo Blue

Titanium White

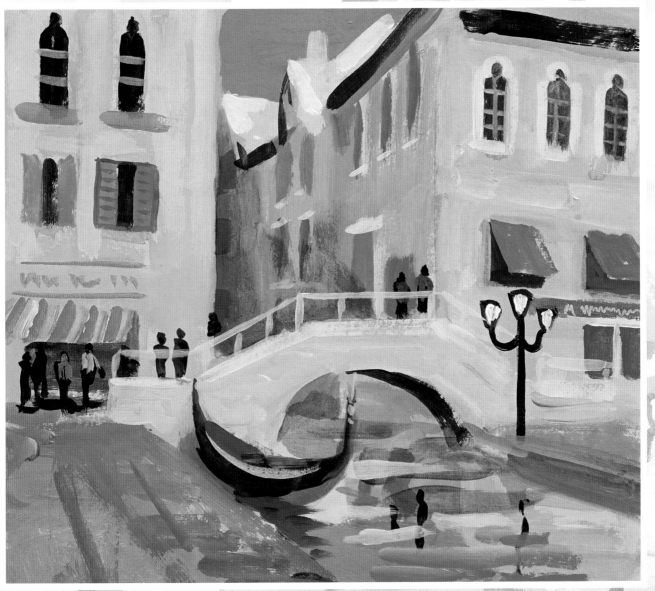

VENICE SCENE (SEE PAGE 114)

This scene has been simplified, but still contains some
tricky bits that need practising before you start. Figures
in a scene add interest and a sense of scale, so it is worth
having a go at some before you get involved in this final
project; the tips on pages 110–111 will help. You may want
to try glazing as part of the image, and pages 112–113
describe how glazing works, so you can add this historic
method to your artistic repertoire.

PAINTING PEOPLE

SUBJECT 6

It's important when adding figures to an image, whether it is a street scene or a landscape, to get the scale of them correct. Remember to check the relative size of their surroundings before you start painting them.

Shadows are important, so when you have painted your little figures be sure to put a shadow under each one. It need not be too dark, but you will find that it anchors the figure to the ground.

People in the distance are not too difficult to paint. I find it is easier to start with the heads, then apply the torso, and add the legs last, making them slightly longer than the torso. Using a dull grey colour means that you can add colours for clothing later. For people coming towards you, put a touch of Burnt Sienna into some Titanium White, and put a blob of that on the head, leaving some dark showing for hair.

Spend a little time practising these figure shapes, then you will be confident when you come to putting some people into your Venice scene.

1 When painting a group of people in the distance it is easiest to start with the heads. Use a dark colour for this, such as a grey or brown.

2 Add a thicker vertical line under each head for the torso, in a paler version of the same colour, with a slightly thinner line to indicate the legs. The length of leg is about the same as the head and torso combined.

3 Different colours can be added to each figure for clothing, but avoid very strong bright colours or the figures will not look as if they are distant.

4 If the people are walking towards us, add flesh-coloured faces on top of the dark heads. Tiny lines in the same colour will make believable arms, and bare legs can be applied using the same colour. Last, add some pale shadows.

When painting figures that are nearer, start with a centre line for them, and gradually make them fatter. To help with proportions, use a unit of measurement. I always use the size of the head, and compare this to other parts of the body; it is usually easy to see the head, and most everybody has one!

1 Build the figure on a pencil 'skeleton'.

2 Once you have the shape and stance of the figure you can fill it out.

QUICK & CLEVER!

Figures are very useful in a painting to give a sense of scale, and add human interest, so it is worth learning how to put them in.

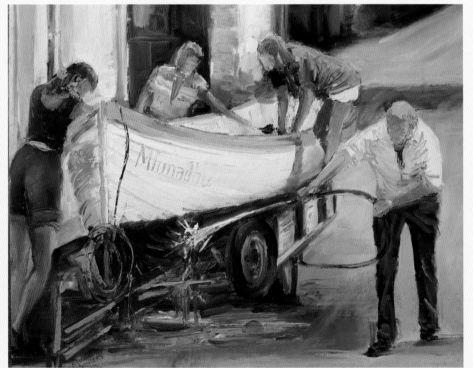

CAUGHT IN ACTION...

If you want to paint people seated, or doing something, you need to refer to photographs so that the proportions and angles of the limbs are correct. Better still, when you have done all the projects in this book, why not enrol on a figure drawing workshop? They are great fun and you will meet like-minded people interested in painting.

This painting, of people cleaning a boat, was done using sketches of figures that I posed in specific ways so that they looked authentic.

GLAZING

Before starting on the Venice project I would like to show you the technique of glazing. You will need to paint a simple scene, maybe some buildings, in tones of pale grey, as shown in step I, and set this aside to dry. Glazes can be used on top of any colour, but by using a monochrome grey painting to start with, the process is easier to see. This is a very traditional method that the old masters used when painting in oils; acrylics are quicker, and easier. You will need some acrylic matt medium. Have a go at glazing before you try it on the next project.

SUBJECT 6

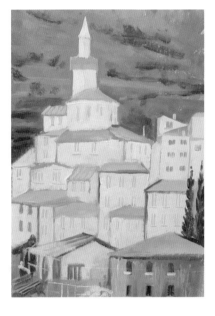

1 I have painted this little landscape on board, using a mix of Burnt Umber, Burnt Sienna and Titanium White. It is now thoroughly dry.

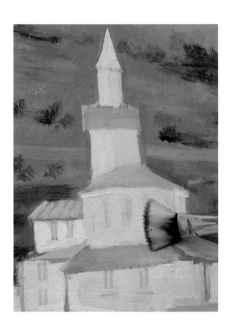

2 With a little Cadmium Yellow Deep and a touch of Burnt Sienna, added to some acrylic matt medium, and a no. 10 synthetic bristle brush, apply some sunny colour to the top buildings.

3 Work down one side with this colour, varying it slightly here and there.

4 Mix a green and apply carefully over the background hill, painting round the buildings.

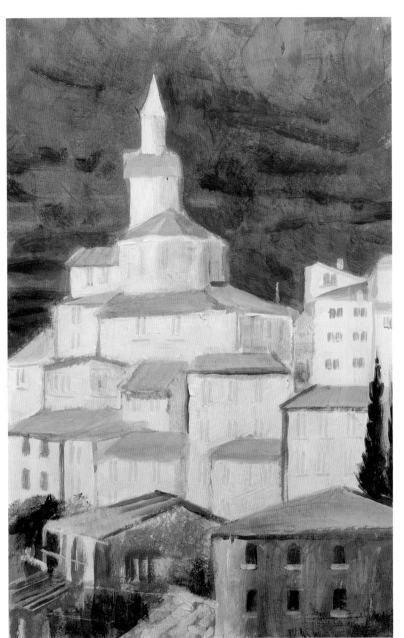

6 Working this way, with tones and then colour, means that you can concentrate on painting accurate shapes and tones, and worry about colour later.

5 Use a pale blue glaze to put in some shadows on the sides of the buildings, taking care to make sure this is not too dark.

QUICK & CLEVER!

Remember to try each glaze out on a piece of scrap paper before using it!

QUICK & CLEVER PAINTING
VENICE SCENE

Now you have had a bit of practice, you just need to get in the mood to paint this sunlit scene. Imagine warm sun, ripples on the canal, and the aroma of Italian coffee wafting on the gentle breeze, with just enough time to do a painting before lunch. Heaven! This image uses most of the techniques that we have already covered, so, if you want to change colours, or add details of your own, feel quite free.

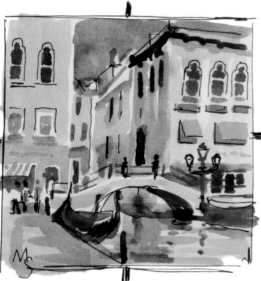

An initial thumbnail sketch helps to plan colours for this project.

1 Prime a board with white gesso tinted with a little Burnt Sienna to make a pale pink-buff colour. Allow to dry. Enlarge the image on to the board using the grid system, with dilute paint and a no. 6 flat bristle brush. Mix a pale grey colour for this and add little brushstrokes to show windows and doors.

2 Mix a medium blue (not too dark) from Titanium White, Ultramarine Blue and a tiny touch of Phthalo Blue. Block the sky in, and paint the reflected colour in the canal, with a no. 12 flat bristle brush. Reflections will come on top of this later.

3 Use Titanium White, Naples Yellow, and a touch of Cadmium Red Light, to block in the building on the left. Add a touch of white with a hint of sky blue, to change the colour for the bottom third of the building, painting around the window shapes. Add a touch more sky blue, to make a cool grey. Paint a thin vertical strip of this above the bridge, for the distant building, with a paler strip to the right for the building next to it.

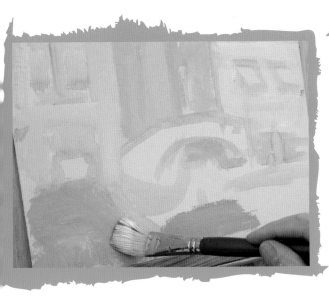

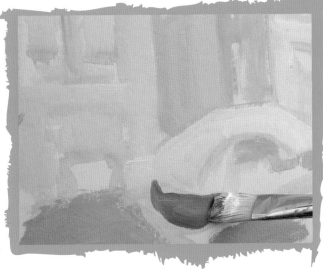

4 With the no. 12 brush, add the warm pink building: use Titanium White with a little Cadmium Red Light. Do not forget to put some of this pink colour under the bridge, with a few horizontal touches for reflections. Finish blocking in the right-hand side with a paler pink. Leave the window shapes unpainted for now. Put a touch of Burnt Sienna into the pink, and add the shape bottom left.

5 Complete the blocking in by adding the canal bank on the right, beside and beneath the bridge, with a mid pink and a touch of Burnt Sienna. Clean the brush, and use it to apply a tilted crescent in bright blue to make a gondola shape in the canal.

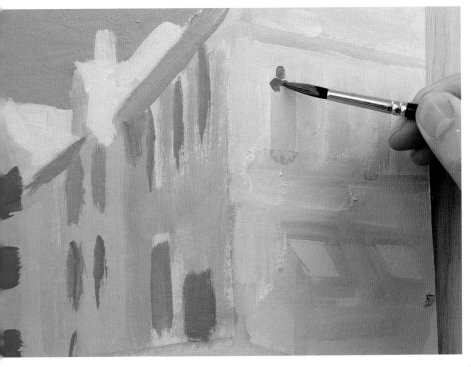

6 Apply some sunlit roofs in the centre of the painting at the top, with Titanium White and Naples Yellow. Using a no. 6 round synthetic sable brush, add some windows, starting with the distant ones in a pale grey, and getting darker as they get nearer.

7 Paint the underside shadow on the right-hand side of the bridge in the same colour as the windows. Add more windows in the left-hand building. Put a mid-grey diagonal strip of shadow at the bottom of the canal bank on the right.

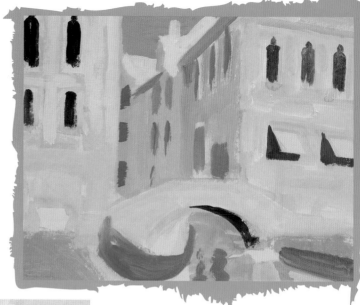

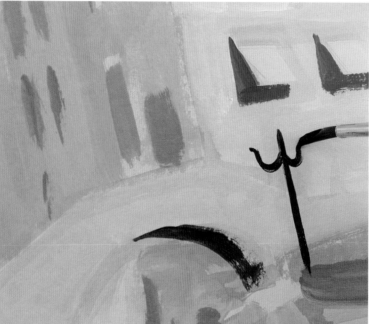

8 Use a mix of Ultramarine Blue and Burnt Sienna with a hint of white for the lamp post and lanterns. To avoid the shakes, make a fist of one hand and use it to support the other. Apply this colour to the inside of the gondola, leaving some of the blue showing. Adding a tiny touch more white to this, put in the shop window, left of the bridge. Use Burnt Sienna and white to scumble texture on the pavement area bottom left.

9 Still using the no. 6 brush, put some red stripes above the window for an awning, with a couple of horizontal red lines to imply a shop sign. Paint a few squiggles to look like lettering; it is best to avoid tiny letters unless you are a miniaturist calligrapher. I am not. Anyway, I do not know what the shop is called!

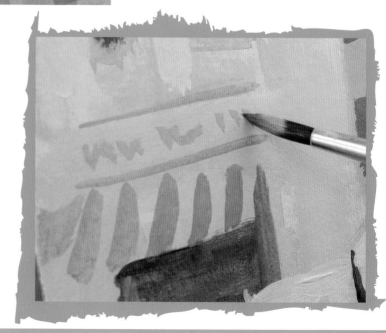

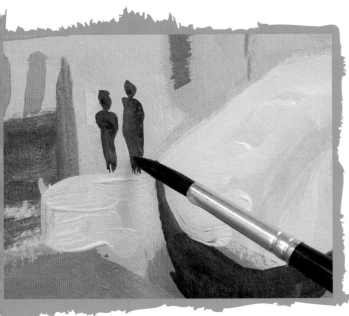

10 Add a few figures beside the bridge. Practise these shapes beforehand. Avoid making heads too large; it is a common fault! Use a dark grey for now, and add coloured clothes later. If you are getting good at figures, put in a few more; I shall leave it up to you. Put a couple on the bridge, and a few squiggles underneath for their reflections.

11 Apply a few more people. It is easiest to start with the heads and put the bodies underneath. When dry, add pale touches for the faces; Titanium White with a touch of Burnt Sienna makes a good flesh tone. Put some of the colour on arms and legs as well, if you like.

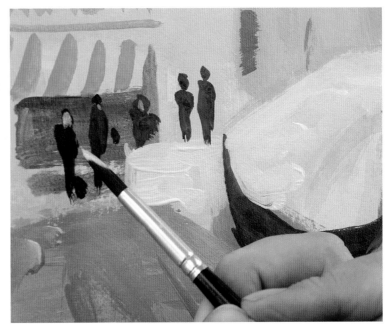

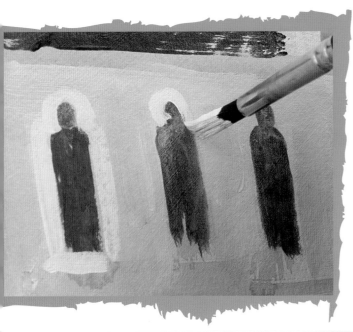

12 Use white with a touch of Naples Yellow to paint around the windows. This needs to be done carefully. Put some light touches around the windows of the distant buildings as well. Use the same colour to put a light line on the top of the bridge and on the edge of the gondola.

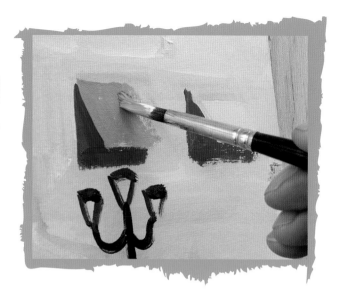

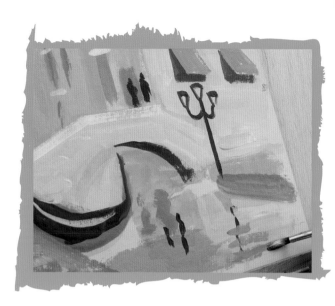

13 Paint vibrant green shutters as a complement to the pink building on the right. Use Lemon Yellow with a little Phthalo Blue, then add a little white. Put them in carefully at the correct angle; do not forget to leave a gap on one side and underneath to give the impression of the window behind.

14 Put some little horizontal lines underneath the shutters to look like reflections in the water. These little touches, with the no. 6 round, add to the vibrancy of the image. The reflections should be slightly less bright than the colour of the shutters.

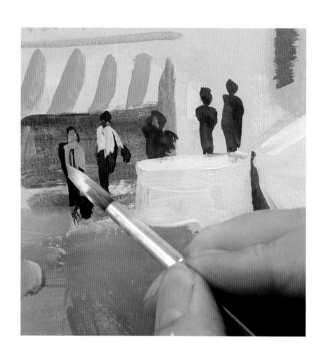

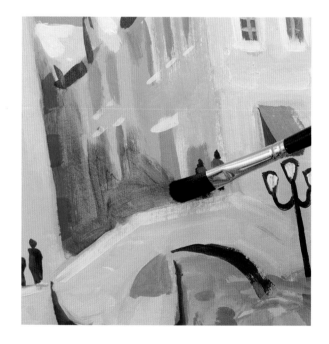

15 Now you can make the figures look more interesting, by carefully putting some bright clothes on them. The ones by the window need light colours for contrast with the dark background; choose which colours you think might work, and use the no. 6 round brush, or smaller, if you prefer. Put some white in the little lanterns.

16 Make a very pale glaze by adding a touch of Ultramarine Blue to some acrylic matt medium. Test it to make sure it is not too strong, and apply it to the distant buildings to imply shadow.

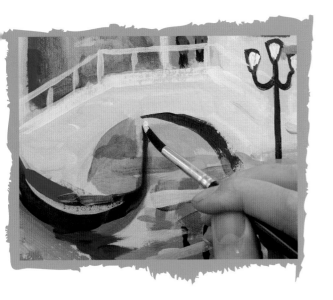

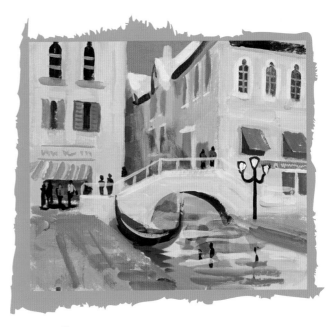

17 Use the 12mm (½in) brush to paint some railings on the bridge and a few light horizontal reflections in the water. Add a dark reflection under the gondola, a touch of red inside it, and a little red sign on the right-hand building.

18 Add a couple of more people on the left, and a few additional colours on the figures. Use the 12mm (½in) brush to put some details on the windows. Treat yourself to another Italian ice cream – you have earned it! Sit back and admire your work.

GONDOLAS

Here is a scene painted with the same colours as the project painting, but utilizing the transparent technique. Painted on 425gsm (200lb) rough watercolour paper, the image uses dry brushwork extensively to impart an old weathered look to the buildings.

It is interesting to compare the different atmosphere developed with these very different methods; you would think that they were painted using different materials instead of exactly the same paint. That is the advantage of acrylics summed up: versatility!

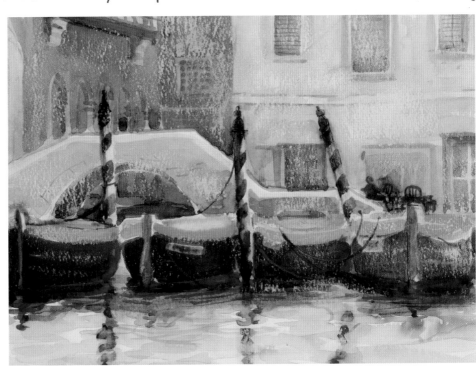

A FINAL WORD

I hope you have enjoyed doing the paintings in this book as much as I have.
Now you are on your own, free to develop your own style and choose your
favourite subjects!

 I am regularly asked by people on my courses or holidays, what I think is the most
important thing about learning to paint. Often my answer is to give them this
little story. A lady was lost in New York. Seeing a 'cop', she went over and asked
him, 'I'm a bit confused. What is the best way to get to Carnegie Hall?' The officer
paused for a split second, then gave his answer, in one word: 'Practise!'

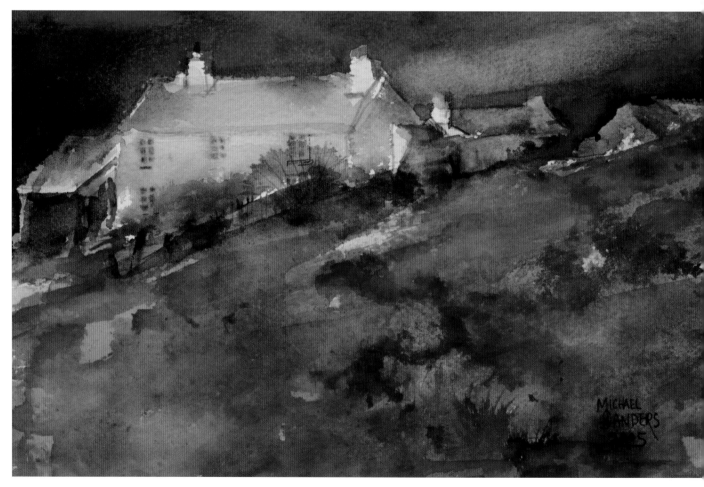

'Evening', painted using the transparent techniqu
from page 2

INDEX